de Meyer

Edited by Robert Brandau With a Biographical Essay

DEMEYER

by Philippe Jullian Alfred A. Knopf, New York, 1976

This is a Borzoi Book/Published by Alfred A. Knopf, Inc.

Copyright © 1976 by Robert Brandau

Introduction Copyright © 1976 by Philippe Jullian

All rights reserved under International and Pan-American Copyright Conventions.

Published in the United States by Alfred A. Knopf, Inc., New York,

and simultaneously in Canada by Random House of Canada Limited, Toronto.

Distributed by Random House, New York.

Photographic acknowledgments appear on pages 158–9.

Library of Congress Catalog Card Number: 75–36796

ISBN: 0–394–49744–9

Manufactured in the United States of America

First Edition

Contents

*Notes and credits
and acknowledgments
follow the portfolio*

DE MEYER

/ by Philippe Jullian

The fifty years between 1880 and 1930 were a transition period between a capitalism in full flower and a capitalism weakened by economic crisis. They were marked by the rise of a social set combining the appearance and privileges of aristocracy with artistic fervor. Though this set was numerically small, it was constantly in the public eye. Incapable of producing creative artists, it nevertheless engendered a climate eminently favorable to artistic creation. It was frivolous, immoral, and useless, according to the standards of our modern democracies. From the aesthetic point of view, however, which is less concerned with morals than with a certain life-style, it was both charming and beneficial.

Truly a society of leisure, busying itself solely with fêtes and fancies, it influenced all those artists who found inspiration in elegance rather than in Nature (as had the Impressionists) or in esotericism (as had the Symbolists). Painters first depicted this society, with all the finery, charm, and illusion of Largillière or Reynolds. They were then replaced by photographers whose capitalist efflorescence we find reflected in old copies of *Vogue*, discolored like flowers pressed in an album. Here are exquisite faces and marvelous moments, captured by photographers dedicated to the service of Beauty enhanced by Fashion, who managed to create the impression of a society just glimpsed as it hurries from a theater to a party, or—as in the case of the Baron de Meyer—to suggest an idealized High Life, transformed into a sort of paradise.

Fashion played such an important part in this woman-dominated world that the works which interpreted it with such brio became quickly, though only temporarily, out of date. In such a society, fashion thrives on derivation rather than originality, and things are relegated to the attic one day only to be rediscovered the next. The rapidity with which this society changed, as well as the fate that hung over some of its more irresponsible members, justifies us today in a certain nostalgia for what appeared to right-thinking people of the time as mere waste or absurdity. After all, a dead society can be judged only by its relics. "Sensible" capitalism has left only imitative architecture, collections of ancient objects—most of which have already been dispersed—and the interminable dinner menus which produce such an impression of boring vulgarity. Capitalism fecundated by aestheticism, on the other hand, has given birth to some marvelous, golden-hoofed black sheep, whose exquisite follies (like the fantastic creations of Beckford or Ludwig of Bavaria) enchant us. These black sheep were shepherded by Wilde, D'Annunzio, and Diaghilev in pastures glittering with Venetian mosaics and flowered with the Savonnerie carpets of the Ritz hotels. Such creatures were concerned solely with the creation of Beauty and remained its incarnation in the eyes of several generations following their own. Their place is somewhere between fiction, whose conventions were too narrow to contain them, and history, in which they no longer had any place. They are part of a legend in which the Melusinas and Morganas become Lady de Grey, the Comtesse Greffulhe, the Marchesa Casati, or Ida Rubinstein. They formed a link between Henry James and Tennessee Williams, between Proust and Scott Fitzgerald. They adored Wilde, then Diaghilev, then Cocteau. Legend has smoothed away the wrinkles and worries which could lead the envious to suppose even for a moment that they owed their success only to some passing whim of fashion. These gilded black sheep have been transformed into myths. Or perhaps they may be compared to those flag-arrayed galleys

which float through the light in Turner's canvases. They would arrive at some theater or palace like ships putting into port, and the bizarre and exquisite spectacle was an inspiration to poets. "They sailed in. . . ." The Edwardian expression justifies the nautical simile.

The artists who portrayed these ships were as different as Sargent and Dali. Serious art critics belittle the talent of Boldini or Van Dongen, Helleu or Bérard, but there is genius in the way they immortalized these frigates, which Picasso himself decked out more than once. From time to time, one of them might strike a reef, for these adventures in search of Beauty were sometimes imprudent and even scandalous. Yet none of the dangers encountered were as redoubtable as those two calamities—one inevitable and the other a constant menace—which were old age and reduced circumstances. An ocean of dollars, Royal Dutch or Suez shares, was needed to keep these exquisite vessels afloat. People watching from the dreary shores would see the chimeras pass by and predict catastrophe, in the name of a morality which was merely another guise of envy. Sometimes they had the consolation of coming across one of these fine ships stranded on some sordid beach, stripped of its flags, or reduced to the state of a *traghetto* plying between Sodom and Gomorrah, or even being consumed in a cloud of opium smoke.

The women who dazzled our parents and grandparents belonged to no special country except that of Beauty, but they did retain certain national characteristics—Italian panache, Slavic charm, English eccentricity, French wit. They lived in an age without passports or exchange controls and in a world where one could live according to one's whim. This world stretched from St. Petersburg to Madrid, from New York to Alexandria, and its two capitals were Paris and London. Apart from a few big hotels, New York offered little scope for this kind of display, nor was it to the taste of America's puritan millionaires. Germany lacked elegance and was too much preoccupied with the importance of the princely families listed in the *Almanach de Gotha.* Austria was not rich enough; Russia was too far away and not entirely reassuring. On the other hand, to have a Viennese baron for a grandfather, besides having certain solid advantages, suggested a sort of exoticism and a vague nostalgia for the East; and to have a Russian grandmother meant, of course, an additional inheritance of disorder, generosity, and inconstancy. From America came more constructive elements; from England the ideal of *chic,* as exemplified by the court of Edward VII; from Paris a passion for Fashion and smart parties. Venice was perhaps the most truly chimeric capital, the natural port for these marvelous ships. From Ruskin to Cole Porter, lovers of Beauty succeeded each other in this sublime and crumbling décor, where some did indeed discover Beauty, others fêtes and festivals.

One can find even more eccentric specimens among the "Café Society" that shed a last luster over Venice, or among today's "Beautiful People"; but here the common bond is money rather than a passion for Beauty, and they are by no means so well-educated as their predecessors. Nor, now that traveling has become so easy, are there any real capitals. Instead, there are merely places which have become temporarily fashionable, but where it is impossible for any artistic milieu to develop. Articles about the Greek millionaire's yachting parties reveal only that there is nothing worth knowing about the people on board, apart from the few tidbits tossed to the popular magazines or an occasional squalid scandal. Nowadays, the very rich tend,

like the governments of totalitarian countries, to be secretive and inaccessible. Both have understood that an appearance of virtue creates a useful barrier and that, above all, a millionaire must never give the impression that he is enjoying himself.

Another reason for this decline is the servant problem. Even the most luxurious hotel can never have the same glamour as the great staircase at Lady de Grey's or the Marchesa Casati's, with a footman posted on each step. The rich have gone the same way as Catholicism—they have chosen simplicity. The cardinals' trains have been shortened, the oratorios have been silenced, the gold has been smeared with gray.

Panache has disappeared from the modern world, and it is to be feared that *chic* will soon be gone too. *Chic* made its appearance in the middle of the last century, invented by dandies for whom there was no art like that of making a fine display. It became the religion of Society, and it is a demanding religion, though a constantly changing one. Its first law is to foresee new fashions without adopting them in advance (which would be termed "eccentricity"). The idea of *chic* is international, as was the idea of honor in the Middle Ages. Not all countries, as we have seen, have the same talent for it, and it would be too easy to say that masculine *chic* is English and feminine *chic* French. *Chic* is not just a matter of clothes. It pervades everything— dealing at cards, serving a salad, choosing a motorcar and even the chauffeur's livery buttons. It has its own language, studded with expressions taken from here and there, but especially from England. The idea of *chic* did not exist while Europe was still ruled by its aristocrats, for although a real aristocrat may be extremely elegant, he will be above all perfectly sure of himself, and thus perfectly natural. *Chic* and snobbery both were born in a changing society, and those who practiced it were less often aristocrats than people aping aristocracy. Thus the most accomplished examples were to be found among the Jews who were beginning to play such an important role in France and England. It is not by chance that Proust's Swann, who is the most *chic* man in fiction, is a Jew. *Chic* was the religion of the Baron de Meyer. Its every nuance was familiar to him. He could spot instantly those who were likely to fail in its pursuit, but was always ready to help those who shared his faith in the surest assets of Art and Society. For this great artist, who was also a great snob, lived in an age when *chic* was synonymous with Beauty.

Toward the end of the nineteenth century, certain enormous fortunes came into the hands of women, who were thus able to play an important part in transforming elegance into an art. Women, of course, have often been influential in aristocratic circles, but, unless of royal rank, they could not spend their fortunes as freely as did some of those whose acquaintance we shall shortly be making. Princesse Edmond de Polignac was one of the most reasonable of them, as the Marchesa Casati was one of the wildest. Later came Daisy Fellowes and Marie-Laure de Noailles. There were also Robert de Montesquiou, of course, and Étienne de Beaumont a generation later, both of whom pursued novelty with truly feminine fervor; but these two aesthetes were lovers of men. It has been said that the decline of a civilization can be measured by the importance of the role played by its homosexuals, and Gibbon—if one reads "pederast" in place of "eunuch"—has much to say about this in *The Decline and Fall of the Roman Empire*. The hero of this present volume and many of his friends certainly behaved rather like perfidious

and magnificent eunuchs in the somewhat Byzantine society that gravitated around the Russian Ballet. Like themselves, the women they admired often confused Fashion with Beauty. They squandered vast sums and wasted the time of innumerable people—in short, they created that climate of excitement which artists find so beneficent and sensible people so scandalous. As for the pederasts who adored them, they encouraged the extravagances which rendered these women ever more delicious and at the same time (thank goodness!) ever more inaccessible.

Scandals are transformed into legend—largely through the imagination of pederasts—at least two generations after that of the people concerned in them. Tradition is handed down by word of mouth, weaving a shroud of memories, inventions, gossip, and adulation—or better still, a gay sail made all of bits and pieces, as were those of these fabulous ships. This magnificent and dissolute international set had a passion for Beauty, but was devastated by social ambition. It had its own appointed painters, and today these are coming into fashion again, though the works do not fetch the enormous prices they did when their creators were alive.

Some of these artists were almost exclusively dedicated to the ornamenting of this court; others did a few paintings of it, or were influenced by it for a time. Most of them, of course, were portrait painters—Helleu, Boldini, Sargent also, in a certain measure, though his models too often represent a boring combination of aristocratic pretentiousness and capitalist self-satisfaction. Later came Bérard, the most charming of them all, who dedicated his life to Fashion (though in reality, and almost in secret, he was an excellent painter). José-Maria Sert decorated the court salons (that is, those of the Waldorf and of the Sassoons) with baroque allegories. In their youth, Tchelitchev and Dali adored these *Vogue* beauties, then deserted them, the former in favor of esotericism, the latter for self-advertisement. Many of Augustus John's portraits pay tribute to Fashion. Van Dongen found his inspiration, if not in its salons, at least in its casinos. Marie Laurencin started with poets and went on to countesses, while Vuillard revealed a taste for luxury from the first. Picasso, always easily influenced, had his Society Period with Mme Eugenia Errazuriz, Étienne de Beaumont, and Marie-Laure de Noailles immediately after his Blue Period. By way of Marie-Laure de Noailles, we come again to Dali and to Balthus. The former, alas, has vulgarized and cashed in on nearly everything he learned from this set.

Certain artists in black and white for whom Art was synonymous with Fashion were working at the same time as these painters and are also being rediscovered. Among them was the Frenchman Drian, who by 1910 was imposing his own style with portraits of Boni de Castellane and Cécile Sorel, and later the American Eric (Carl Erikson), who interpreted the elegance of Daisy Fellowes and Mona Williams. Vertès too should not be forgotten. Then, finally, came the great photographers whose works are just beginning to appear in museums—men like de Meyer, Edward Steichen, Man Ray, Horst, and Hoyningen-Huené. They replaced the painters and draftsmen, but remained under their influence and served the same ideal.

Baron de Meyer's name certainly comes first on any list of the great photographers of elegance. The place is his by right of a talent that transformed fashion photography into an art. It is also his by age, since he was born in 1868, three years before Proust, and like Proust

Baron de Meyer—an early self-portrait

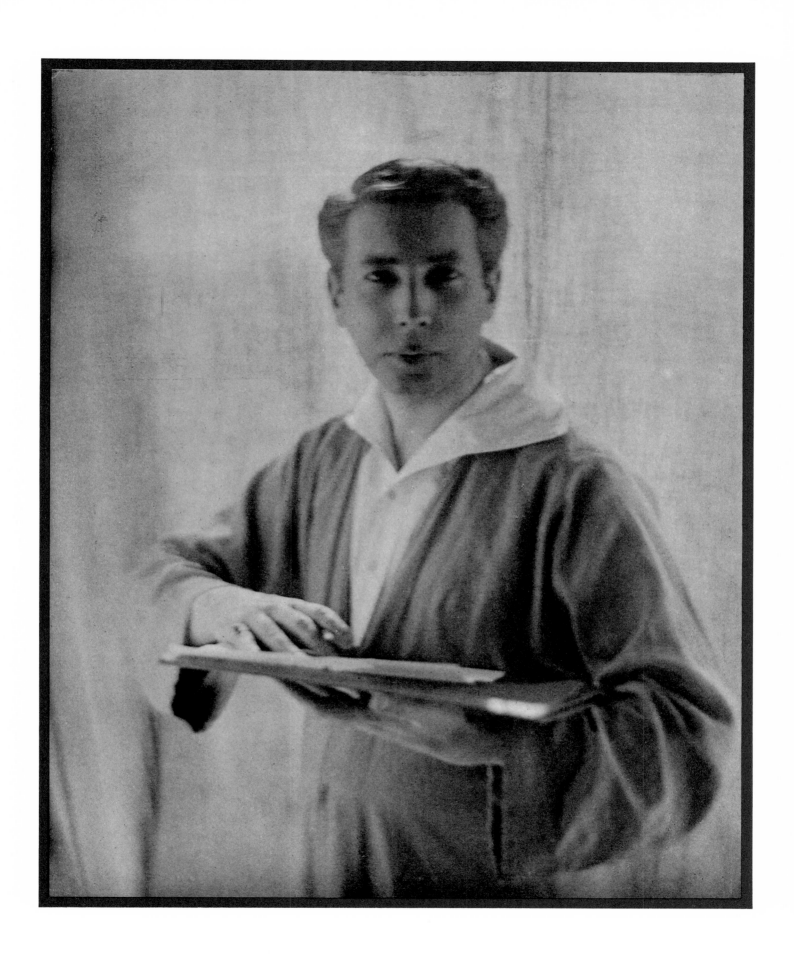

(who was also half Jewish), he was fascinated by high society. But whereas the novelist soon began to caricature the people who had once dazzled him, the photographer strove to endow living beings with all the glamour of the fictional Guermantes.

Fashionable painters had been portraying this glamour ever since Winterhalter, but, at the end of the nineteenth century, no one could have imagined that a mere photographer would ever discover their secret. The first photographers had indeed produced excellent portraits, but they were the sort of exact likenesses which would be sure to irritate fashionable people and pretty women. Here were none of those blurred effects which blot out wrinkles, none of those flattering colors, but only the exact truth, such as one finds in the drawings of Ingres. Only a woman as sure of her own elegance as the Empress Eugénie would have consented to pose endlessly for the photographers Nadar and Disdéri, but hers was a staid, sober elegance, in spite of the complicated dresses which appear in the russet tones of these old *clichés*. The Empress Elisabeth of Austria, too, looks less fascinating in Rebendig's camera portraits than in those of the painter Winterhalter.

There were, however, two women who succeeded in imposing their own conception of beauty on their photographers—the ·Comtesse de Castiglione and Sarah Bernhardt. The first was a striking Italian beauty who became the mistress of Napoleon III and preferred photographers to painters. She posed chiefly for Disdéri, wearing ball gowns or extravagant fancy-dress, and was even photographed in the guise of a nun. A few years later, about 1875, Sarah—whose beauty was then like that of Garbo—directed her photographers (including Nadar) in such a way that she appears in their portraits to have the sort of poetic beauty which became the ideal of the Symbolists. In England, it was Julia Margaret Cameron who photographed the beauties of the Pre-Raphaelite circle, imitating Rossetti's contorted poses and Burne-Jones's hairstyles. Most of the late Victorian photographers, however, copied the poses and lighting of the Royal Academy artists, or of society painters like Carolus Duran or Bonnat. We must mention two talented photographers of Proust's Paris—Reutlinger and Otto. Their work lacks the charm of the Baron's but heralds its *chic*.

In London, Wilde's women friends were posing for La Fayette, who did some excellent portraits of the superb Lillie Langtry, while Alice Hughes lent poetic charm to the elegance of the Princess of Wales. Portrait photography in the nineties was influenced as much by the aesthetic movement as by snobbery. On the Continent, only actresses and demi-mondaines authorized the sale of their likenesses, but in England great ladies like Lady Brooke (later Countess of Warwick), Lady de Grey, and many others who moved in the Prince of Wales's circle had no objection to seeing their portraits displayed in the tobacconists' windows beside those of popular actresses. Thus they came to be known as "professional beauties," and a little later we find their likenesses being used—with their permission—to advertise soaps and powders. This taste for beauty and great names was encouraged by the invention of photogravure, which made it possible to transfer photographs onto copper plates and print them like etchings. Publishers brought out magnificent albums, or "Books of Beauty," in the style of the "Books of Beauty" illustrated with steel engravings which Lady Blessington had published fifty years earlier.

The finest of these books appeared in 1897 and portrays a collection of aristocratic beauties, including Lady Diana Manners (later Cooper), then aged five. Opposite each portrait appears a sketch or poem by the model in question. All these portraits look alike, whether they are paintings or photographs, since photographers had at last managed to achieve the aura effects and half-tones demanded by clients resolutely hostile to reality. These photographs, printed in sepia on expensive paper, pointed the way for young de Meyer.

Leafing through this "Book of Beauty," one immediately recognizes the influence of two painters—Watts, who always gave his clients a Pre-Raphaelite expression of mystery and spirituality, and Whistler, as regards composition and arrangement of light and shade. Whistler's popularity with his elegant sitters owed far more to the subtlety of his taste than to the quality of his painting. Socialites like Robert de Montesquiou and Lady Archibald Campbell were enchanted by this erratic dandy with his unerring sense of publicity. People were shocked or fascinated by his way of living, the simple Chinese blues and whites that decorated his Chelsea home, his Japanese bouquets, his insolence, and his Empire furniture. In Whistler's view, beauty and *chic* were inseparable, and his models posed in the attitudes the mannequins of the great Parisian dressmakers were to adopt fifty years later. One of these models was a ravishingly pretty and already amazingly sophisticated girl of sixteen named Olga Caracciolo, who was to marry Adolf Meyer in 1899.

Photographers in the eighties were still copying the Pre-Raphaelites, and an Edwardian magazine entitled *The Amateur Photographer* shows that in the nineties and even later they were imitating Whistler's "symphonies," or artificial arrangements. The compositions resemble those of his Venetian etchings, with no outstanding details and nothing especially picturesque, but plenty of atmosphere. Baron de Meyer in particular was greatly influenced by Whistler's art and personality.

In the Baron's work we find a society à la Henry James, for James himself was a fervent aesthete, incarnating Wilde's dream of "the critic as an artist." De Meyer was twenty when the aesthetic movement was at its height, and Ruskin was his Bible—Ruskin, whom a journalist quoted as saying, apropos of de Meyer's photographs: "Not all the mechanical or gaseous forces of the world or all the laws of the universe will enable you either to see a colour or draw a line without that singular force anciently called the soul."

Thus we recognize Whistler's taste and Sargent's models, as well as the cult of Beauty. Yet neither a work of art nor a dazzling career can be entirely explained away by good taste and social success. We may as well admit at once, even before we introduce him, that without his wife, without Olga, Adolf would have remained merely a fashionable decorator, or a snob who took photographs, or a homosexual ballet fan (and, indeed, he was all these). It was she who inspired him to learn from the great painters and to make the contacts through which he came to frequent the two most brilliant courts of the prewar era—those of Edward VII and of Diaghilev. Adolf and Olga, as mutually dependent as a couple of trapeze artists, traveled over Europe, collecting commissions and admirers.

They were invariably *élégants;* they remained young—terrifyingly young—to the very end. Their careers were like those of two amazing tightrope walkers, balancing, forever on the verge of catastrophe, in the blinding light of the Ritz hotels, those circus rings of Society. The Baron seems hardly to have existed before he met Olga. Indeed, he had not even the title which sounds so opulent when it precedes a Jewish name and which makes one think at once of the Barons de Rothschild, de Guinsbourg, and d'Erlanger.

Not much is known about de Meyer before his marriage, but there is enough to suggest that he had ambitions which he was able to realize through this marriage. According to the memoirs of the painter Jacques-Émile Blanche, Adolf Meyer was born in Paris—in Auteuil, to be exact, in the rue La Fontaine—of a Jewish father and a Scottish mother whose name was Watson (perhaps she was simply English). Meyer-Watson, the name he adopted, must have been a sign of dissatisfaction with this very ordinary background, but "the effect was ridiculous rather than imposing," recalls Blanche. In *Always in Vogue,* the memoirs of Edna Woolman Chase, we read: "De Meyer was born in Paris of a French mother and a father who was German, although his forebears had for several generations been living in Finland. The family name was really Von Meyer, but he changed it to the French version. There was always a slight air of mystery about him and some people suspected his title of Baron to be spurious. . . ." According to Cecil Beaton, who writes in *British Photographers:* "Mr. Demeyer Watson, later to be known as baron Demeyer, the Debussy of photographers, has not been placed high enough in the hierarchy of photographers. Although he was born in Austria and worked for a great many American dollars, much of his work may be claimed by England, since he was settled here for many years." And finally, here he is in *Who's Who* for 1905, at the height of his social success: "De Meyer, Adolf Edward Sigismond, baron of the Kingdom of Saxony; b. Paris, son of Adolphus Meyer and Adèle Watson. M. 1899, Olga, daughter of duke Caracciolo. Educ. Dresden. Recreations: music, painting, photography. Address: Sand Lea, Datchet, Bucks." All this tells us little about Adolf Meyer's life before he became Baron de Meyer, but we note that photography comes third on the list of his pastimes and appears to be merely the hobby of a gentleman.

Adolf Meyer-Watson (the hyphen was a first step in the direction of aristocracy) was brought up in Paris by his mother. The father had died young, leaving a certain fortune. He must also have had connections, since about 1895 we find the young Adolf in London and already introduced into the fashionable Jewish set that revolved round the Prince of Wales. Two financiers—Sir Ernest Cassel and the Baron de Hirsch—were helping the future Edward VII while he awaited his throne. They paid his debts and gave splendid parties for him and his friends. The august friendship thus acquired had already shed a certain luster—*chic*—over social positions previously based solely on money. When Edward came to the throne, the sums invested in the Prince of Wales also began to bring in enormous dividends. Big business, in league with the Crown, ruled the Empire, though without actually misappropriating public funds or provoking financial scandals (swindling was not *chic*). Most of these Jews were of German origin and descended from the "Court Jews," of whom the Rothschilds, who had served the Elector of Hesse, were the most brilliant example. There were also the Bischoffheims, the Speyers, the

Olga de Meyer, photographed by her husband

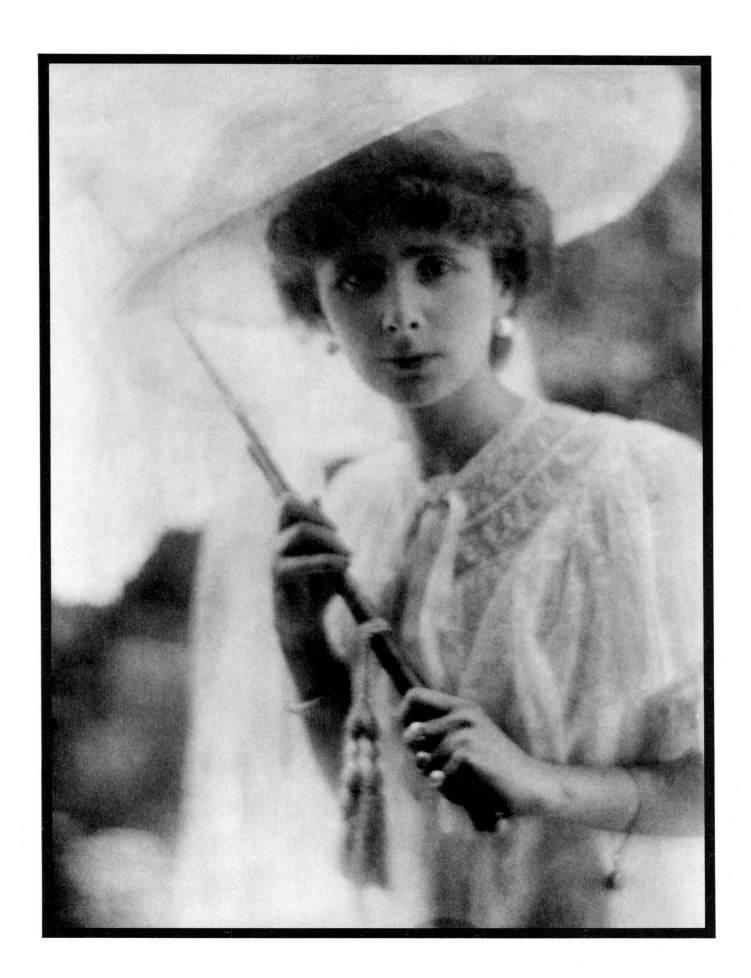

DEMEYER

Goldsmids, and others. One very important family—the Sassoons—came from the Orient. They were descended from a Grand Rabbi of Baghdad of the late eighteenth century and had founded huge business firms in Hong Kong and Bombay, so that they became known as the "Rothschilds of the East." The Sassoons had a huge mansion in Brighton, decorated rather in the style of the Paris Opéra, with paintings by Bouguereau. The Prince of Wales often visited them, and it was probably there that he first met young Meyer, who was a friend of the family.

Jacques-Émile Blanche describes de Meyer as "the curly type of Jew, oiled down and gentlemanly." A photograph shows him as tall, very conscious of the effect he is making, with regular features, a slightly heavy jaw, and fine black eyes with rather too long lashes. His whole person radiates a self-satisfaction tempered by charm. Adolf was handsome and had delightful manners. At parties, he was both decorative and useful. He was attentive to the older women, danced with plain young ones, and could get even the surliest guests to talk. He could help the mistress of the house compose marvelous bouquets or choose a dress to match the table decorations. Thus he received more and more invitations to increasingly elegant houses. His beauty too was the surest of passports to this society impregnated with aestheticism.

Very soon, Adolf made friends with a remarkable woman and became her page and confidant. Lady de Grey was descended from the Earls of Pembroke, but she had Russian blood through her grandmother, née Woronzow Romanovich. Everything about her was on the grand scale and as far removed as possible from any kind of mediocrity. She was very tall, very beautiful, very passionate, and very rich. She was also a music lover who devoted all these advantages to the service of Art. Lady de Grey had forced Covent Garden to play Wagner. She was said to have had a liaison with the tenor Jean de Reszke (whose portrait adorned cigarette boxes and represented a certain sort of *chic*). She was a friend of Oscar Wilde's and Sarah Bernhardt's. It may have been a desire to perpetuate Lady de Grey's beauty that determined the artistic vocation of Adolf Meyer-Watson. It was, of course, to be an amateur vocation. A gentleman might just possibly publish his poems or perhaps exhibit his watercolors, but as for photographing his friends and selling the prints . . . impossible! A photographer was then a little man one sent for at the end of a house party to photograph its members, grouped in order of precedence round some illustrious guest. Or else it meant the owner of a studio, such as La Fayette or Reutlinger, who used tricks of lighting and background so that their models looked as if they had been posing for some Academy painter. As for Adolf, he gave his charming friends a look either of Whistler or of Burne-Jones. In the first case they were dressed in a simplified version of the current fashion; in the second, in draperies that seemed to clothe their souls rather than their bodies. The most intellectual among these beauties, indeed, were known as "The Souls."

In the same way, once he had gained entry to the royal circle and become a veritable court artist, de Meyer managed to photograph Edward VII and his family in such a way that they looked both majestic and agreeable. The King's large belly appeared smaller, the pouches under his eyes diminished. As for Queen Alexandra, who was "divine" by nature, de Meyer rendered her enchanting. The sovereigns sent these portraits only to their families and close friends—they were never official. One saw them, in Fabergé or Asprey frames, in the bou-

A signed portrait of Edward VII, King of England

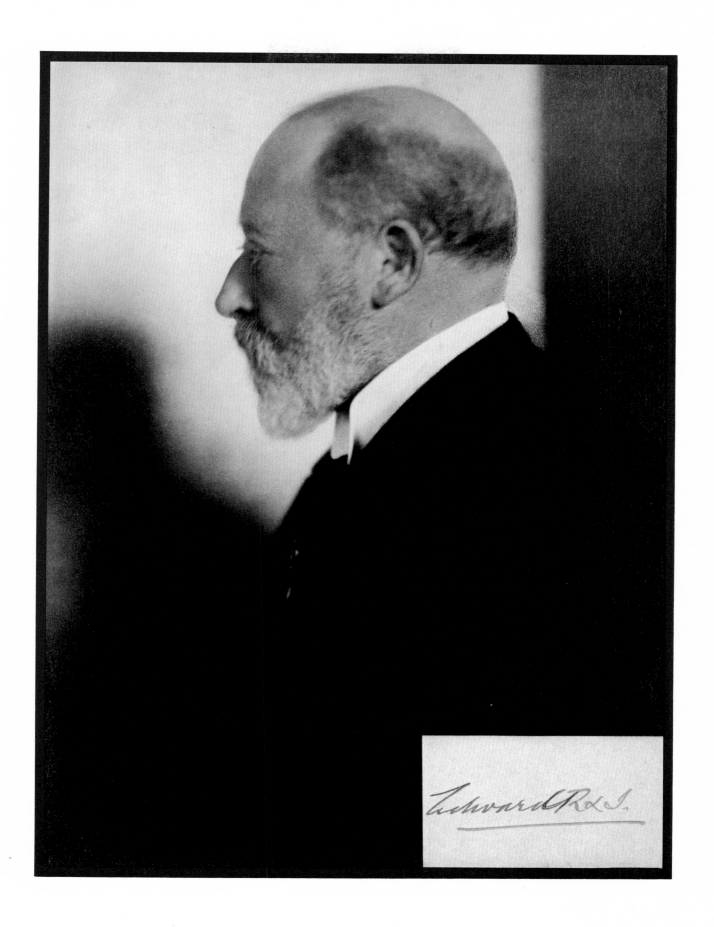

doirs of the most elegant grand duchesses or on the bed-tables of a few ladies who were sufficiently tactful to be both admired by the King and liked by the Queen. The Germanic side of Adolf was certainly useful to him in a court which had so many links with the German royalties. Nor could any Englishman have been such a perfect courtier.

Apparently Adolf did not need to work, and he even seems to have had enough money to lead the life of a young man of fashion. However, his position as hanger-on to a few very rich families could lead to nothing—except, perhaps, to a rich marriage. (Henry James's stories are full of men of this type, who cannot quite be said to be living by their wits.) But Adolf's admiration for magnificent women like Lady de Grey was not of the sort which leads to married bliss. He preferred men—but all the more discreetly, since the Wilde affair had created a panic in homosexual circles. Luckily for Adolf, he met at the Sassoons' house, in 1897, the one young woman who was perfectly suited to him, since she shared his social ambitions and artistic tastes, had little money but a great many connections, and was even more *chic* than she was beautiful. The homosexual Jew and the woman who had come down in the world thus had all that was needed for an ultramodern version of marriage à la mode; but in addition there was one factor which changed everything: Olga's godfather was none other than—in the words of Henry James —"that fat, vulgar Edward."

The Prince of Wales became King on January 22, 1901, and London life changed overnight. Buckingham Palace had been a mausoleum, only occasionally opened up for some frigid ceremony. Now it became a sort of Versailles revised by Ritz. The rich—and there had never been so many of them—realized that it was *chic* to throw their money about. For the next ten years, the luxury of the London court was truly amazing. Maharajahs, South African magnates, visiting Americans competed there with the Duke of Westminster, Lord Lonsdale, Sir Ernest Cassel, the Sassoons, and the Rothschilds. Never had there been so many servants, tiaras, orchids, sables. It was then that César Ritz declared, "I realized there was a clientèle in England ready to pay any price to get the best." For many of these customers, his Piccadilly hotel replaced the private houses which had become boring and failed by then to exclude anyone but second-class snobs. Adolf Meyer-Watson was one of the first habitués of the dining room overlooking Green Park. All his friends were becoming very important. Lady de Grey, a close friend of the new Queen, had become a leading figure at court. The Sassoons were invited to Windsor, and the King continued to favor them with visits to their Brighton home. It was then that the sovereign intervened like a good genius in the destiny of Olga and Adolf.

Let us now consider the career of Olga Caracciolo and see just what she brought her husband in place of a dowry. Olga's mother had already inherited from her exotic forebears a taste for the sort of adventures that ruin a social career. Her father was a M. Sampayo, a French diplomatist of Portuguese origin; her mother was an American, granddaughter of General de Saint-Jean-d'Angély, whose wife had been one of the beauties of Napoleon's court. Blanche Sampayo had fallen in with her parents' wishes in the most docile manner when they married her to a Neapolitan, the Duke Caracciolo. Hardly, however, was the ceremony over,

when the young wife threw a cape over her white dress, jumped into a carriage where her lady's maid awaited her, and was driven to the station. The dismayed families were left without news for a considerable time, until she reappeared in Dieppe, accompanied by a beautiful little girl named Olga Alberta. The "Alberta" had been added because her godfather was Albert Edward, Prince of Wales. This naturally started the rumor that Edward VII was her father, and it was encouraged by the fact that he had given the Duchess a charming villa at Dieppe on the cliffs overlooking the Channel. It was called Villa Olga but became known as Villa Mystery. It is possible that Edward VII was in fact her father; there were many rumors to that effect, and according to Anita Leslie, granddaughter of Lady Leslie (née Leonie Jerome of New York), both Olga herself and the King acknowledged the rumors to be true. Later, in London, writes Mrs. Leslie, "he asked my grandmother to take pains because of Olga's very delicate position in society. 'You will I know be *sympathique* to Olga,' said the King. 'She has been brought up without friends.' "

Dieppe at that time was a fashionable watering place, frequented by most of the elegant people one meets in Proust's Balbec. There were the still-beautiful Princesse de Sagan, whom the novelist transforms into the Princesse de Luxembourg; Robert de Montesquiou; and above all the Comte and Comtesse Greffulhe, both of whom were young, handsome, and immensely rich. In August, the Greffulhes were visited by their cousins La Rochefoucauld and Chimay, but in September the Count went shooting, and his wife, encouraged by Montesquiou, invited such painters as Helleu and Boldini. In fact, everyone who was anyone went to their Villa La Case—everyone except the Duchess Caracciolo, who, for all her distinction, had to content herself with evenings at the casino and dinners to which men were invited without their wives. She had come down in the world; she was *à-côté*, as they used to say in aristocratic circles in Paris. Fashionable parents forbade their children to play with little Olga, and they could only admire her lovely auburn hair from a distance.

Occasionally, the Duchess got her revenge. A yacht would put into port and a handsome, tawny-bearded man, already going a little bald, would disembark with the discreet fuss of semi-incognito and be driven to the villa. He never stayed more than two or three days, during which he heaped presents on his godchild while the Duchess's admirers kept out of the way, unless they were invited with other gentlemen to play baccarat or chemin de fer. Meanwhile, the fine ladies stayed at home, bitterly regretting that they had not made themselves more agreeable to the Duchess. Blanche, strangely enough, looked very much like the Princess of Wales: the same long, pale face, curls bunched on the forehead, wasp waist, and tailored suits. Helleu might have described her as he did Alexandra: "No expression, a silver mirror, a double peony."

Various young men frequented Villa Mystery, but none was more flattered to be allowed a glimpse of all this grandeur than Jacques-Émile Blanche, a plump young man, curious about everything, who was said to have a great future as a painter. He was indeed to become a sort of French Sargent and to remain for the next half-century the most intelligent portraitist of fashionable and literary society, even though he allowed his passion for high life to dominate his talent. Blanche was inclined to be spiteful, but his admiration for Olga—who, born in 1872, was ten years younger than he—lasted to the end of his life, and he imparted it to his

friends. It was thus that Degas came to Dieppe, accompanied by Mrs. Howland, a Frenchwoman married to an American. Degas was enchanted by the ladies at Villa Mystery—ladies whose grand air, he said, reminded him of thoroughbred horses. George Moore, on the other hand, liked women as painted by Renoir, and retorted: "By Jove, you're all after the girl, a fine Mélisande for the stage, with her beautiful hair down to her heels. She's paintable, I admit, but as to one's daily use, I should rather have the mother than the child. Too slender for me . . . you know my tastes."

Whistler came to Dieppe in his turn. Olga fascinated him and inspired a "scherzo"—"Arrangement in Pink, Red, and Purple," showing her reclining on a sofa, holding a fan—and another portrait with her silhouette in dark gray against a black background, a hat in her hand, one foot advanced, and a faraway look. When Whistler's admiration for the sixteen-year-old girl became known, she was launched. Soon all the fashionable painters were using her as their model. Helleu did several portraits of her, admiring her catlike profile, almond-shaped eyes, and graceful, slightly angular movements. Boldini would plead with her, rolling his r's: "I beseech you, Donna Olga, stay still for just one second . . . I'll give you a cigarette and not tell your mother . . . I'll sing you a song by Verdi. . . ." And she would burst out laughing at the impassioned declarations of this fat little man with globular eyes, who looked so like a frog.

Olga preferred the company of another painter—this time, a very handsome one. Charles Conder was a blond giant with the pink complexion that goes with tuberculosis. He painted in watercolor on silk fans, taking his subjects from stories by his friend Oscar Wilde, or portraying crinolined ladies chasing the Bluebird, or Watteau-like figures in Whistler-like colors. A close friend of Toulouse-Lautrec's, living the bohemian life of Montmartre, he was a strange companion for a young society girl. But was Olga a young society girl? She could be better described as what a fashionable novelist of the day, Marcel Prévost, called a *demie-vierge*. People were beginning to gossip about her escapades: At the age of twenty, she had decided to learn fencing, and now she was one of the best foils in Europe, besides being a first-class shot. Later, in London, Olga de Meyer joined the Whitehall Gate Fencing Club, which included a few very eccentric ladies, such as Lady Colin Campbell and the Honorable Mrs. Cadogan, who lived with a boa constrictor. The magazines showed pictures of Olga dressed in fencing clothes, and this led people to suppose she had masculine tastes.

Olga's reputation for precocity gave Henry James the idea for one of his most famous novels, *What Maisie Knew*. The facts are different, but the general atmosphere is that of the villa, and he tells the story of a little girl who, her parents divorced, guesses their adventures when she visits one or the other. The elegant, immoral mother is very much like the Duchess.

Henry James was always fascinated by the so-called innocence of children. Though Maisie is not as totally corrupted as are the children in *The Turn of the Screw*, she is shown as unnaturally mature, and nothing escapes her notice. Once, when he was discussing Olga with Jacques-Émile Blanche, James confided, "My dear friend, your Dieppe is a reduced Florence; every type of character for a novelist seems to gather there." And later, "The enchanting Olga learnt more at Dieppe than my Maisie knew."

A Sargent-like study of Rita de Acosta Lydig

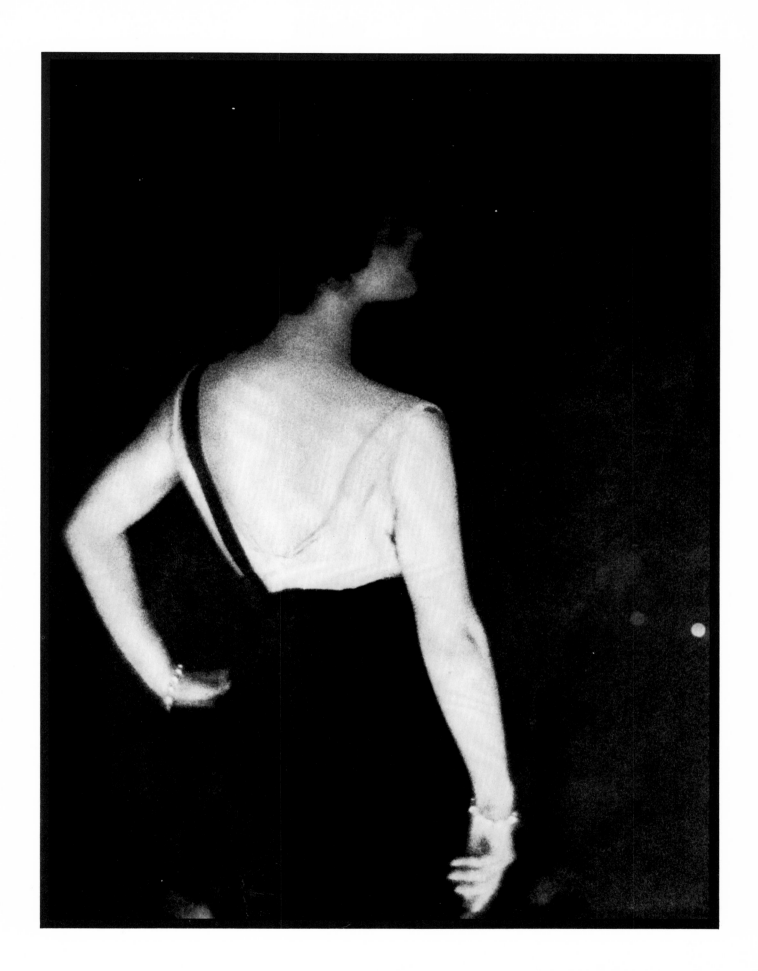

Olga Alberta had been treated as a child for as long as possible, thus enabling her mother to conceal her own age. Then, when the Duchess saw her admirers turning into old friends, more inclined to give good advice than presents, it was time for Olga to stop playing the part of a little girl and start looking around for a husband who would help them both to keep up their position in the world. There was an offer from an Italian nobleman, the Duke de Gallese, whose sister had just caused a scandal by marrying Gabriele D'Annunzio. Perhaps he did not feel like risking a new scandal, even for a girl as beautiful as Olga, for in 1892 she married another Italian, Prince de Brancaccio, who was twenty years older than she. The couple lived for two years in Rome, and the marriage was annulled in 1896. Well before that date, however, we find Olga in Monte Carlo, kept by one of her mother's old lovers. After that, she came to live in Paris, where for a time she wrote the social column for the paper *Le Gaulois*, owned by a great snob, Arthur Meyer, a friend of the Duchess's. M. de Blowitz, the London *Times* correspondent in Paris, was another of her protectors. In those days, society columnists were as important in Paris as they were not long ago in America. But Olga was too young to make a true place for herself; if she had tried, she would have found herself debarred from all the really elegant houses.

When her mother died, Olga took refuge in London, where she was received by Sir Charles Rivers-Wilson, who had been one of the Duchess's admirers. In spite of this, Lady Rivers-Wilson treated her like her own daughter and introduced her to Mayfair. After that came visits to the Sassoons in Brighton, and it was there that Olga met Adolf. One of Meyer-Watson's first known photographs shows the young Olga wearing a long, full, black dress, with a huge hat on her little, proudly held head. The eyes behind the veil would be beautiful if they were not so piercing. Elegance and melancholy . . . it puts one in mind of some self-exiled royalty—perhaps Elisabeth of Austria.

Once married, thanks to the royal protection, the Meyer-Watsons soon became one of the most fashionable young couples in London. Edward VII wished to favor them even more highly by inviting them to his coronation. Since all the seats were reserved for officials, or for peers and their families, some excuse had to be found. The new King solved the problem by asking his cousin the King of Saxony to give Adolf the title Baron de Meyer and appoint him chamberlain, so that he could join the King's delegation to Westminster Abbey. The German sovereign complied with his powerful cousin's request—all the more readily since he had been told that the young man's father had been born in his states. Adolf, now an authentic baron and wearing a fine uniform with a golden key embroidered on the back, was thus able to take his place in the diplomats' wing, while Olga attended in the King's Box, on which all eyes were focused. Mrs. George Keppel, blazing with beauty and diamonds, was positively enthroned in the front row, with Sarah Bernhardt beside her. Olga remained tactfully in the second row, with a few other young society women in whom Edward VII was more or less interested. Gossip, of course, decided at once that she was or had been or was about to become the King's mistress. As he probably believed she was his daughter, there can hardly have been any ground for this slander.

The young couple settled down in a pretty, comfortable red brick house in Cadogan Gardens, between fashionable Knightsbridge and artistic Chelsea. They entertained

lavishly—chiefly at luncheon parties, since evenings were taken up with the theater and balls. Occasionally, they gave concerts or small fancy-dress balls, which gave Adolf a chance to devise marvelous costumes for Olga. Their furniture was simple and magnificent—Chinese screens, Renaissance chests, Queen Anne chairs; the color scheme, pearl-gray and old rose; their guests, cosmopolitan socialites. One of the most typical was the beautiful Mrs. Deacon and her even more beautiful daughters. She was an American, and the mistress of Prince Doria. One of her daughters had married Count Palffy, an irresistible and immensely rich Hungarian. Another had married the Duke of Marlborough (divorced by Consuelo Vanderbilt), while a third had married a Prince Radziwill. One also met Mrs. Lydig there. She was considered one of the most elegant women of her generation, and Boldini, just before the Baron, had done a marvelous portrait of her. The de Meyers received a great many actors—London being the only capital where they were admitted in Society. There were Mrs. Patrick Campbell and Beerbohm Tree, as well as such playwrights as Henry Bernstein, Arthur Wing Pinero, and Somerset Maugham. Bernstein was a stout man who looked like an Assyrian bull and wrote plays about adultery and money—that is, about the essentials of his own life. He had planned to marry rich, beautiful Romaine Brooks. She had merely laughed at him, but he found plenty of consolation elsewhere. Since he had never slept with Olga, he remained her faithful friend. As for Somerset Maugham, he made a rich marriage and never ceased to regret it. Pinero's *The Second Mrs. Tanqueray* is a picture of the de Meyers' unconventional set. Such painters as Sargent, Conder, and Sickert were constant visitors. Jacques-Émile Blanche, who came to London each year for the "season," would hurry at once to Cadogan Gardens to hear the latest gossip. If the King arrived while he was there, he hid behind a screen; one day he overheard Olga violently attacking the Entente Cordiale in favor of an alliance with Germany.

This circle became the nucleus of the International Smart Set, which degenerated into Café Society. Occasionally, the frontier between this circle and the true aristocracy was made apparent, as, for instance, when Mrs. Keppel remarked to Lady Neuman, a rather pushy friend of the de Meyers', "Dear Maud, may I call you Lady Neuman?" In this circle where the de Meyers shone so brightly, nearly everyone had some kind of skeleton in his closet—a grandfather who had been a moneylender, a kept woman for a mother, a rather too rich lover, a brother who had known Oscar Wilde—but Olga was so tactful that people forgot what lay in *her* closet. Still, for all her success, certain doors remained closed to her, or else only half-open. When, for instance, the Duchess of Sutherland received at Stafford House, the Baron and Baroness were naturally not included among the first series of guests invited to dine before the ball, nor the second, who came in for coffee. They were merely part of the crush who arrived at eleven. They were invited, on the other hand, by the very beautiful Duchess of Rutland, a talented sculptress, to her weekend parties at Belvoir Castle, where they met highnesses, millionaires, and fashionable painters. But when the old Duchess of Devonshire recognized Olga, she held out only two fingers to her. Such slights, however, were mere shadows over a marriage which, though it was never consummated, was a complete success. No one knew if Adolf and Olga really adored each other, but they got on perfectly, which is more important in the long run.

People sometimes wondered what the de Meyers lived on. In those immensely rich circles, it was considered normal that the wealthiest should send an occasional check to the less favored so that they could appear to be living on the same scale. Those close to the King could amass vast fortunes—as Mrs. Keppel did simply by entrusting her interests to financier Sir Ernest Cassel. Olga, however, felt the need for a steadier income and organized a sort of theatrical agency, bringing foreign impresarios into contact with London theaters. With Lady de Grey's support, she was able to arrange performances of operas, and later of the Russian Ballet, at Covent Garden. Meanwhile, she had a liaison with the famous French singer Vanni Marcoux.

The King rarely attended Olga's large receptions, but he was known to take tea with her frequently. On these occasions, other visitors were tactfully turned away. Olga, who never missed a new play, would tell him what would amuse him, and what would be a little too risqué for the Queen. Sometimes, as we have seen, she chanced talking politics. She was bitterly hostile to France, where she had been humiliated in her youth, and favored Germany, whereas Mrs. Keppel was for the Entente Cordiale. Compared with the imposing Mrs. Keppel, so sure of her position, the de Meyers counted for much less than was commonly supposed—but enough to be taken seriously by ambassadors and financiers anxious to approach royalty. Since unkind gossip had been unable to decide whether Olga was the King's daughter or his mistress, it was put about that she was a procuress, and we find a vestige of this slander in the memoirs of a *Vogue* editor: The de Meyers had "a place on Crown property in Dorset, discreetly subsidized, so went the rumor, by the baroness's royal father, who would come there occasionally with the lady in whom he was interested at the moment." As for the Baron, he took photographs (was he paid for them, or not?) of the celebrities who frequented his wife.

It is time now to discuss Adolf de Meyer's talent; for, though this talent thrived on social life, it was, far more than that life, the real *raison d'être* of this great artist. Later, the fact that his art had been at the service of aristocracy and fashion would lead serious-minded people to refuse him a place among the great photographers. Thus Helmut and Alison Gernsheim, in their concise but comprehensive *History of Photography*, do not even mention the Baron de Meyer—though his work was much admired by the master Alfred Stieglitz, who became aware of the Baron's photographs soon after the turn of the century. Beginning in 1903, de Meyer exhibited his pictures at the London Salon of the Linked Ring, of which he was a member, and elsewhere, sometimes together with the work of two other important photographers, Alvin Coburn and Edward Steichen. Adolf de Meyer's exhibits met with a success that was due not to snobbery but to the echoes of Whistler and the aesthetic movement which the public recognized in them. His best portraits were those of his friend Coburn, a bearded, romantic figure. Two schools were represented at these shows. One comprised realistic landscape photographers who used subjects dear to such Victorian watercolorists as Birket Foster—"Ploughing in Auvergne" or "The First Daisies"—and anecdotists who produced compositions entitled "The Little Chimney Sweeps" or "The Gay Musketeers." On the other hand, there were artists who applied the principles of the Symbolist painters and conceived of photography as a marvelous marriage between art and sci-

24 / de Meyer

A portrait of Gertrude Vanderbilt Whitney

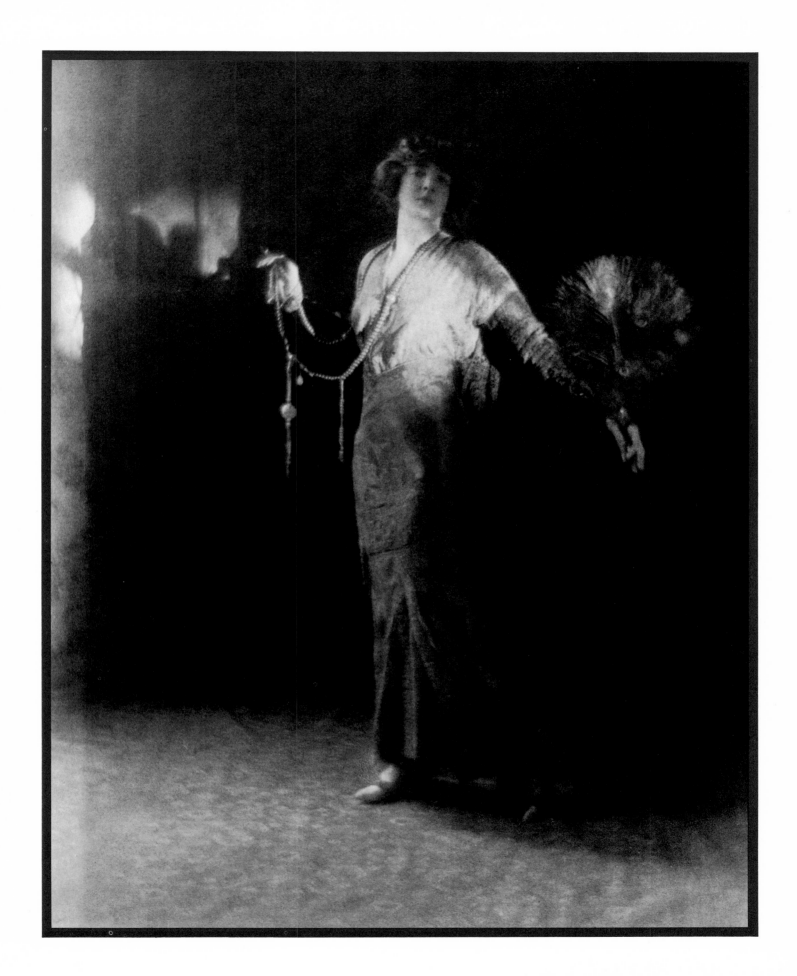

DEMEYER.

ence. One beautiful album, *Esthétique de la photographie,* published in Paris in 1900, sets out the principles which brought esteem to the Baron de Meyer and which he continued to practice. The book is illustrated with Pre-Raphaelitish portraits of *Belles Dames sans merci* and *Demoiselles élues.* Here we find many of the techniques used by the Baron—back-lighting, lights lowered just to touch the hair or used to outline a profile, an absolutely plain background. This work equates the photographer's art with that of the engraver, insisting on the importance of the inks and papers employed. The newly introduced gum print process made it possible to retouch the images and juxtapose two exposures, as Edward Steichen did in his famous portrait of Rodin face to face with his *Thinker.* The Symbolists had a literary influence on these avant-garde photographers which went well with studies resembling those of the Impressionists (especially Monet): reflections in water, light filtering through leaves. . . .

De Meyer was among those who became bored with the anecdotal manner of the exhibitors at the London Salon and broke away to found, in Vienna, a movement called Secession, in the style of the Art Nouveau movement. Stieglitz invited him to exhibit with this group at the 291 Gallery on Fifth Avenue in New York, in company with Steichen, Clarence White, and Gertrude Käsebier. A letter from de Meyer to Stieglitz written in 1906 insists that his photographs be exhibited separately and not mixed together with other works. De Meyer held one-man shows in 1907 and 1912, and their success was such that his pictures were often reproduced in photogravure in Stieglitz's luxury magazine, *Camera Work,* as well as in *The Craftsman.* A 1914 issue of the latter magazine contains the following observations about de Meyer: "He deliberately focuses his camera not upon the sparkle of an eye but upon the light that illuminates the eye. He has somehow become possessed of the material wonder-stone, the talisman of insight, and uses it as a lens! When he photographs a tree, its storm-resisting spirit shines through the bark of the twisted, staunchly fighting branches." Thus, de Meyer's art continued to be poetic and spiritual, and the most trivial subjects were bathed in the unreal charm of Symbolism. Sir Cecil Beaton was right to call him later "the Debussy of photographers." De Meyer's art, which resembles painting in that it aims at presenting an image of the world both poetic and *chic,* was further described by Beaton:

"His was the triumph of mind over the matter of mechanism. By using a soft-focus lens of particular subtlety he brought out the delicacy of attractive detail and ignored the blemishes that were unacceptable. Utilising ladies in tiaras and silver lamé as his subject matter, he produced Whistlerian impressions of sunlight on water, of dappled light through trees. De Meyer managed to convey his enjoyment of a subject, and he never conveyed too much: he was not afraid of producing an almost empty photograph."

His ability to suppress unnecessary detail had already been stressed by *The Craftsman* of October 1914 in an article concerning an exhibition in which a number of still lifes had been on show: "He is bent, in fact, on translating his material into a fantasy of abstract beauty. It is almost a rendition of matter into music, wherein the notes are values and their relations and combinations form the harmonies. And to this problem, which is a blend of the

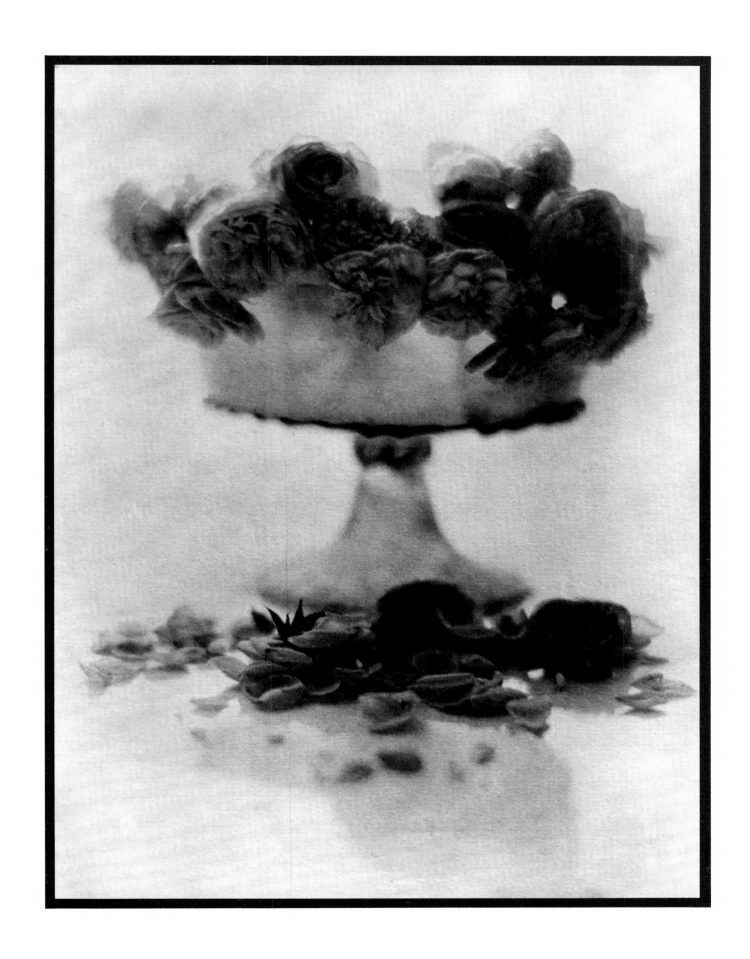

mathematical and artistic, he brings, on the one hand, an analysis of vision, scientific in its acuteness and precision, and, on the other, a sensitiveness of feeling and a conscientiousness and skill of craftsmanship that are extraordinary. Compared with these prints, which have the delicate perfection of some choice example of Japanese lacquer-work, too many other photographers seem technically inefficient.''

Adolf and Olga had two great friends in Edwardian London. One was Baroness d'Erlanger, who, in 1900, was a sort of forerunner of the Bright Young Things of the twenties. She had a great talent for interior decoration and redecorated her house from top to bottom every time she took a new lover. Her portrait by Romaine Brooks shows her to be tall and majestic. She had been born in the faubourg Saint-Germain in Paris and had married a banker who looked like a big cat. Catherine d'Erlanger owned houses in a number of places: a Moorish palace near Tunis, a Palladian mansion on the Brenta. Strangely enough, she spent the end of her life in Hollywood, where she became manageress of a bar. She enjoyed extravagant living, and in the nineteen forties this was more possible in California than in Europe.

The second friend, Mme Errazuriz, was a Chilean who lived in a little house in Cheyne Walk, where she received numbers of artists. She too had posed for Helleu and Boldini. Conder had been in love with her, but her greatest friend was still John Singer Sargent, her neighbor in Chelsea. He was by this time overwhelmed with commissions for official portraits, and the good-tempered Doña kept him amused. Romaine Brooks, who carried on the Whistler tradition and whose models were often the same as those who sat for the Baron, was often to be met at her house. Later, Mme Errazuriz came to live in Paris and met Picasso—but that is another story. She had a nephew, Don José Antonio de Gandarillas (Tony), with whom Sargent was— very discreetly—in love. Small, slim, with a snub nose and small, protuberant eyes, Tony, at the age of sixteen, knew ''everyone.'' Felix Youssoupoff invited him to St. Petersburg; he visited the Casati in Venice. He was a great friend of Ronald Firbank's, Augustus John's, and Osbert Sitwell's. He became Olga's page and Adolf's confidant.

Baroness d'Erlanger, Mme Errazuriz, and Lady de Grey (by then Marchioness of Ripon) often spent Sunday or a whole weekend at the de Meyers' Thames-side house at Datchet. On the other side of the river, the royal standard floated from a gun turret, as if to protect their pleasures. Jacques-Émile Blanche often came down to paint the river boats, all gleaming with brass and mahogany, as they made their way upstream, surrounded by dinghies rowed by splendid young men in white flannels. Gramophones played Gaby Deslys's songs; the popping of champagne corks echoed the click of croquet balls. The lawn was bordered with white poppies and lilies, among which gamboled Leff, the Baron's whippet. But Adolf's masterpiece was the Blue Garden. ''Its wall was painted pale blue to match the sky, and opposite this wall of azure was a clump of dark trees, veiled in a blue mist from the Thames. Part of this flowering rectangle was taken up by a path, paved with irregular marble slabs, leading to an old wrought-iron gate, decorated with della Robbia figures, which opened on to the orchard. Everything here was blue, every variety of blue, and in the shade of these vertical spikes grew a confusion of Canterbury

bells and salvia. Ever indiscreet, the clematis entwined themselves at will" (Blanche: *La Pêche aux souvenirs*). The Baron had yet another idea: The dining room table was covered with looking glass so that one had the impression of dining on the river, reflected through three tall windows.

So many novelists have been intrigued by Olga that one may be forgiven for evoking certain characters from fiction in this house which was so perfectly English that it could have been conceived only by a foreigner. One can get a very good idea of the life the de Meyers lived there from the romantic novels of Elinor Glyn, a splendid woman who was the mistress of Lord Curzon, or from the society novels of Ada Leverson (Oscar Wilde's "Sphinx") or of "Dodo" Benson, the somewhat frivolous son of an Archbishop of Canterbury. As for their guests, one has only to look at the portraits by Lavery, László, Romaine Brooks, and, of course, Jacques-Émile Blanche.

Edward VII died on May 6, 1910, and the "Edwardian pageant" came to an end. A dull, old-fashioned couple came to the throne. A famous cartoon by Max Beerbohm shows the late King's financier friends asking each other anxiously in the hall of Buckingham Palace, "Shall we still be welcome?" Sassoon, Beit, and Rothschild were now the de Meyers' best friends. The couple's situation changed considerably now that Olga's godfather—that dear, stout old gentleman, with his fits of coughing—would never again take tea at Cadogan Gardens.

As for the de Meyers' enemies—that is, all the people who had been furious at the favors showered on them—they cried, "The King is dead, long live the King!" and felt sure the too-brilliant couple could never console themselves by doing the same. They were soon disappointed. The de Meyers cried, "Edward VII is dead, long live Diaghilev!" At the first performances of the Ballets Russes in Paris, they were in the front row, applauding, vibrating with excitement, in ecstasy. They were at the suppers where dancers, artists, and society patrons met after the performance. They were amusing and decorative—exactly the sort of people with which this new despotic and malicious monarch liked to surround himself. They lacked only a great deal of money—but they knew an enormous number of very rich people. When the company came to London in June 1911, after its triumph in Paris, the de Meyers already considered themselves as its unofficial impresarios. Olga arranged lodgings for the cast and organized dinners, backed by Lady de Grey, who did for Diaghilev in London what another great beauty, Comtesse Greffulhe, had done in Paris. Indeed, she did even more, since she was in love with Nijinsky, who danced for her alone in her garden at Coombe.

The de Meyers had become indispensable. Through them, one could gain entry into the enchanted world of the Ballet, which made everything else appear out of date. In his enthusiasm for this revelation, the Baron took his camera into the wings. The company had its official photographers—Bassano in London and Bert in Paris—but their photographs have a deflating accuracy, affecting us rather as do Bakst's costumes when on wax mannequins, looking like gaudy castoffs: the magic has disappeared. As Cecil Beaton said of Nijinsky: "We have heard of the leap, the lightness, the dynamic agility. It is hard to reconcile the simpering, muscle-bound clod of the Bassano pictures with the verbal reports that have come down to us; but the frivolous de Meyer, with his camera, pioneer spirit, and touching zest, spent an afternoon photographing

Le Spectre de la rose, the Faun from *L'Après-midi,* the Slave in *Schéhérazade,* the Prince of the *Pavillon d'Armide.* The results of that afternoon lead one to appreciate that this strange-looking dancer did, in fact, possess a steel-trap agility, the gaiety of youth, the lyrical and exciting qualities which have now become a part of history."

Diaghilev thought these photographs admirable, but it was a long time before he could persuade the Baron to publish them. From then on, Olga and Adolf were to follow the itinerant career of their new sovereign. They were most often in Paris, where they became friendly with a woman who had recently joined the same circle, Misia Edwards. Misia Godebska was half Polish and had learned piano with Fauré and poetry with Mallarmé. Her first husband had been Natanson, an avant-garde publisher, and her second a huge Levantine newspaper proprietor named Edwards, through whom she enjoyed a sumptuous existence; and when the Russian Ballet arrived, she appointed herself its sponsor. Misia had made herself a place in the fashionable world in a single season, thanks to Boni de Castellane, who found her madly amusing. At the time when we make her acquaintance, she was the mistress of José-Maria Sert, a Spanish painter with an immense talent for decorating millionaires' salons rather in the style of Tiepolo. Misia was not as well-bred as Olga; she had more imagination and was less perfectly elegant. She had equal love for beauty and money—that is, luxury—and she always managed to share this luxury with such friends as Debussy or Stravinsky, Toulouse-Lautrec or Vuillard. Misia was untruthful, generous, incredibly diverting. She became Diaghilev's greatest friend and created for him a climate of ecstasy, interrupted by fits of giggling, quarrels, tittle-tattle, and the disgrace of some friend or member of the Ballet. The de Meyers never fell into disgrace.

Venice was King Diaghilev's true capital. Between tours, he would take a rest in this theatrical, worn-out city, beloved of aesthetes because it was so cut off from the world in which they were forced to live. D'Annunzio had sung its praise in his finest novel, *Il Fuoco,* and the eccentric Marchesa Casati—"the only woman who ever surprised me"—lived a "unique life" there, in an unfinished palace. Her clothes owed more to Gustave Moreau than to Poiret.

Each September, the de Meyers rented the little Palazzo Balbi-Valier. They were inseparable. One saw them, dressed in white, gliding along the canals, or arriving—she adorned with plumes and he in a dinner jacket—in the dining room of some palace bathed in that light which was always slightly veiled by mist. There they might meet the Austrian highnesses Hohenlohe and Thurn und Taxis; Italian princes Olga had known during her Roman period; La Duse, who would come to rest in her house at Asolo after some exhausting tour; a few very distinguished Americans—friends and, above all, models of Henry James's; or two Frenchwomen who received writers in their ravishing palazzo near the Salute. They were entertained by the magnificent Countess Morosini, who was said to be the mistress of the Kaiser. With the Marchesa Casati, the de Meyers prepared strange and sumptuous dinner parties; a guest at one of these was a wax figure which was said to contain, in the place of its heart, an urn holding the ashes of one of the Marchesa's former lovers. No expense was too great for the Marchesa when she wished to create a moment of beauty. One day, she invited a few friends into a drawing room filled with

Nijinsky dancing in Schéhérazade, *London 1911*

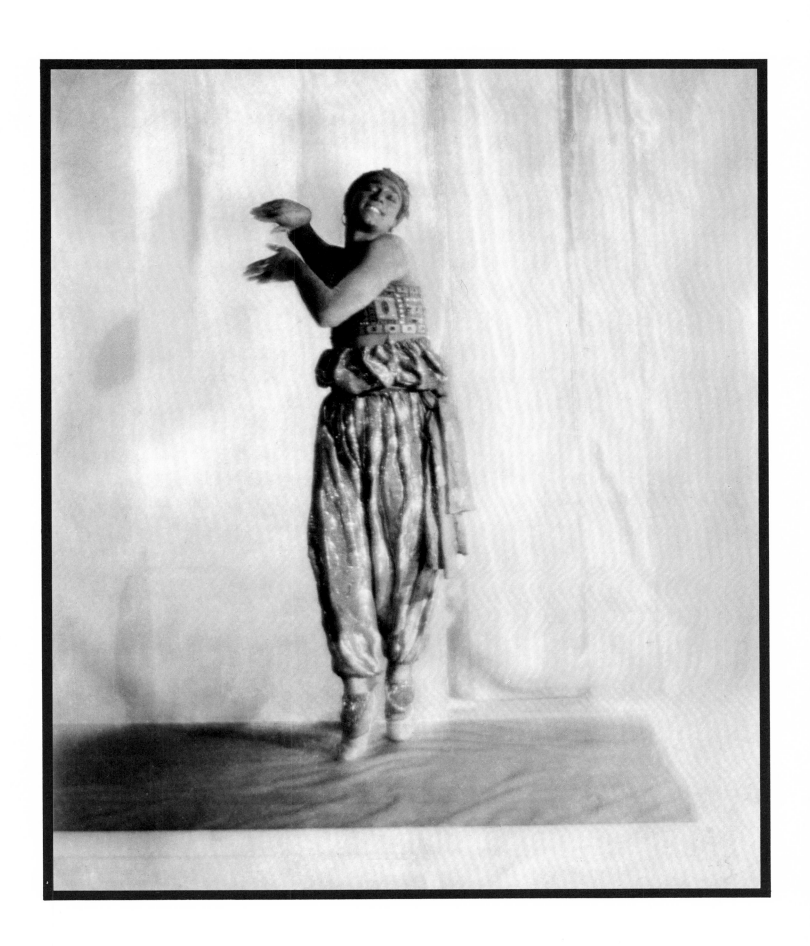

peonies; a long-haired white monkey was let loose to leap on the furniture and tear off the petals. "How divine," she said. "Exactly like a Chinese painting. . . ." In a spirit of contradiction, the Casati had herself photographed by the Baron in the simplest possible way, adorned only with innumerable necklaces and smoking a cigarette. This picture was discovered—among a good many others, it must be admitted—at D'Annunzio's bedside after his death.

D'Annunzio, the Casati, and the de Meyers often met in a little medieval palace behind the Fenice Theater. The designer Fortuny, who was a cousin of the composer Reynaldo Hahn, one of Olga's great friends, had set up a studio there where patterns from dresses worn by figures in Botticelli's and Carpaccio's paintings were copied onto velvets, satins, and linens. Evening cloaks for Doge's ladies and tea gowns for Lucrezia Borgias were made up there to the order of women bored by the current fashions. Comtesse Greffulhe and La Duse were clients, and Proust dressed his sequestered heroine Albertine in marvelous gowns inspired by Fortuny. Today, it is still possible to visit the palace, with its theatrical draperies, ecclesiastical furniture, and Symbolist pictures. Here, under a film of dust, one can discover an excellent example of the aesthetic atmosphere Adolf loved.

Princesse Edmond de Polignac, who was one of the great patronesses of the Ballets Russes, had a palace on the Grand Canal, and the de Meyers soon became constant visitors there. Her numerous nephews called her "Tante Winnie." Her younger brother was the handsome Paris Singer (lover of Isadora Duncan, whose school cost him as much as her extravagant ways). The Princesse owned a considerable part of the shares in Singer sewing machines. Majestic and austere, she cared little for dress, and spent her fortune on the arts. She was extremely musical and commissioned scores by Fauré and Debussy, and Stravinsky's earliest works were performed in the salon of her Paris mansion, beneath a ceiling painted with Sapphic scenes by Sert. The Princesse adored women, and on several occasions there was nearly a scandal. (Robert de Montesquiou once inquired of one of the Polignac nephews: *"Comment va votre tante Berlitz?" "—?—" "Oui, Berlitz: l'école des langues."*)

The Princesse de Polignac was especially susceptible to Olga's beauty and intelligence, and also—since she was not entirely free from snobbishness—to the de Meyers' reputation for having an important place in English society. It was soon being whispered that she had replaced the King as Olga's protector. Olga was said to be teaching the Princesse to fence, and the latter had transformed one of the salons in her palace into an armory, where the two ladies practiced, wearing white tights and metal masks over their faces. A great deal was said—much of it certainly inspired by the jealousy of people who had neither Olga's beauty nor the Princesse's wealth. Unfortunately, Olga was not sufficiently musical to share Winnie's greatest interests, and soon she had a rival who was ugly but had a fine voice. There were jealous scenes. Also, the Princesse became irritated by the Baron's familiarity, and one day, when he had addressed her as "Tante Winnie," she was said to have retorted, *"Tante vous-même!"* Jealous tongues then invented the story that the Baron had sent her a challenge to a duel, worded: "If you are the man you pretend to be, you will fight me tomorrow morning at the Lido." Scene after scene led to the inevitable rupture.

It must be admitted that there was something equivocal about the de Meyers, and in a photograph taken about 1913, this *louche* aspect is very evident. For all her impeccable elegance, her turban with its aigrette, her chinchilla-trimmed bodice, Olga has the piercing eyes of an adventuress; while the Baron, in his Savile Row suit, has grown flabby and has acquired a somewhat Middle Eastern look.

For a while, Adolf and Olga preferred not to be in Venice at the same time as the Princesse, so for several seasons they rented a *yali* on the Bosporus—one of those houses, generally built of wood, where the pashas came to breathe the country air. Aesthetes had learned from the novels of Pierre Loti about the dilapidated beauties of Constantinople. Such painters as Frank Brangwyn and Lévy-Dhurmer had evoked the colorful tumult of the port and the hills where minarets and cypress stood out against a mauve sky. The Baron took some photographs— very much in the Symbolist style—of Abdul-Hamid's capital. The couple were invited to the embassies which owned the *yalis* neighboring their own. In 1912, Constantinople was a political rather than a social center, and while the Ottoman Empire crumbled away, Russians, Germans, and the English intrigued to gain influence. Regarding these visits to Turkey, it was said that the de Meyers were acting as spies for Germany—which would explain how they were able to live in such luxury without having much money of their own. Rumor multiplied when they spent a season at Tangier a year after an inopportune visit by the Kaiser's gunboat *Panther* to Agadir— which had nearly sparked off a European war. In fact, the couple were probably attracted by the climate, the picturesqueness of the Moroccan port, and the easy pleasures it offered. The de Meyers were among the first to colonize the little town, which has since become a suburb of Sodom. There they met some of their friends—the fashionable painter Lavery and his wife, who was a famous beauty, and the English consul, who lived in a seaside house with a wonderful garden. Lady de Grey had been in love with this consul, but he seems to have had deviant interests, since, as an attaché at the Paris embassy, this charming man had been known as *"la tante cordiale."* The Baron sent photographs of exotic Moroccan types to the exhibitions. Re- turning through Spain, he brought home a series of admirable images that make no concessions to picturesqueness, and some portraits that echo the elegance of Zuloaga, a fashionable painter of that time. *The Craftsman,* which reproduced a number of these prints, wrote, "His interpretation of Spanish life might be mistaken for reproductions of paintings."

The premiere on May 29, 1912, in the Théâtre du Châtelet, of the *Prélude à l'après-midi d'un faune* caused a scandal. Debussy's music and Nijinsky's erotic dancing, which ended in spasms on the nymph's scarf, angered devotees of Tchaikovsky and embarrassed those who had applauded the orientalism of *Schéhérazade.* The audience was bewildered by the (rela- tive) simplicity of Bakst's costumes, inspired by archaic Greek sculpture, but the people who counted, the high priests of the cult of Beauty, were transported. (According to the malicious Jacques-Émile Blanche, Rodin's admiration for Nijinsky was more in the nature of love; he says he found the Faun, between sittings, clasped in the arms of the white-bearded prophet.)

Adolf de Meyer's enthusiasm was such that the artist finally triumphed over the gentleman, and he decided to publish photographs taken during rehearsals. The album would, of course, be luxurious and appear in a limited edition reserved for the happy few. For his publisher, he chose the excellent draftsman Paul Iribe, who was an important figure in Poiret's circle and later became Chanel's lover. With its extremely neat typography (perhaps inspired by certain Greek inscriptions) and the quality of photographs (faint yet clear, and reminiscent of bas-reliefs, where certain details—hands or torsos—seem like fragments of some broken frieze), this album was far in advance of its time. It prefigured the Art Deco style, but is in better taste. As an art book, it is a model of simplicity and balance. The illustrations are not reproductions but real photographs printed on very slightly silvered paper and tipped in. Diaghilev was enthusiastic. Here was the ballet as he had dreamed it might be; and in these images Nijinsky appears like Youth itself, while the nymphs seem slightly stiff. "All these albums will sell like hot cakes," declared Diaghilev; but these were cakes of gold, since the first fifty copies, printed on Japan paper, cost 250 francs each—an enormous price at that time—and the other two hundred copies, printed on paper that was hardly less luxurious, 150 francs apiece. Three contrasting texts helped to swell the slim volume: Rodin's was a tribute paid by genius to genius; that by Jacques-Émile Blanche was a slightly more reticent tribute to good taste; and finally, there were a few pages by Jean Cocteau offering tribute from the poetry of the future. A reproduction of a Bakst water color, "Faun with Scarf," served as frontispiece, and the work was dedicated to the Marchioness of Ripon (Lady de Grey). It left the printer on August 15, 1914.

This month of August, so portentous for Europe, almost proved fatal to the de Meyers. They were in London when war broke out. Immediately, all the people who had been annoyed by their elegance remembered the Baron's ties with Germany. They recalled his mysterious journeys and no less mysterious income, and that Olga detested France. In the general frenzy, the de Meyers were again accused of being spies, and their friends advised them to leave Europe. The Speyers, famous merchant bankers and friends of the de Meyers, were in the same predicament, though they were naturalized and also had received a title. In their house in Grosvenor Square they had been accustomed to giving musical evenings at which Strauss and Mahler were played. The Speyers are said to have chartered a yacht and taken the de Meyers with them to America. As for the book, the Baron declared later that the whole edition had been sent to the United States on a cargo boat that was sunk by a German submarine. It is more likely that the publisher had remaindered it because there were no more buyers. Even Diaghilev himself, who said constantly that it was the finest thing about his work ever done, did not possess one, and there are in existence now only a few, rare copies.

The de Meyers' flight was only one episode in the collapse of the Russian Ballet at the declaration of war. Diaghilev was cut off from Russia but managed to re-create his ballets in Madrid—where he met Mme Errazuriz again—then in Rome. With the same energy, Adolf and Olga, in New York, a city they detested, managed to keep afloat without losing their prestige. They were penniless, since their monetary assets had been frozen in England, and had only a few friends among the Europeanized Americans who had returned to New York.

Nijinsky in Le Spectre de la rose, *Paris 1911*

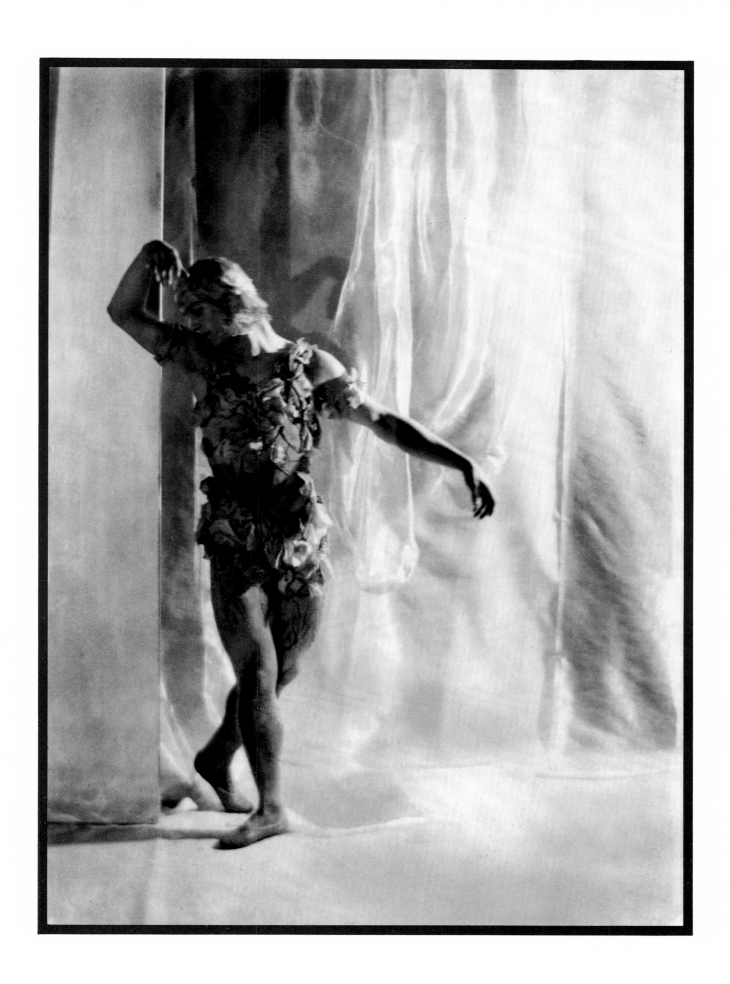

There, in a world of tremendous opulence, where there was little place for beauty unless it were of the fleshy kind, the Baron made up his mind at last to earn his living as a professional photographer. Only one magazine had the combination of *chic* and taste which the de Meyers found indispensable. *Vogue* had been founded in 1892 by two rich art lovers and bought in 1909 by the publisher Condé Nast. With the help of Edna Woolman Chase, who became editor in 1914, he made it into the most elegant magazine in the world. Looking through the numbers dating from the period of the de Meyers' arrival, one is surprised to see the enormous amount of space given to society news—as much as used to be given to the subject in the English *Tatler.* Until the creation of *House and Garden* there was a section on interior decorating; fashion took third place, with excellent drawings and feeble photographs. Only very luxurious reviews like *Les Modes* could afford fine photographs by Reutlinger or Otto. Around 1914, however, Condé Nast turned to a printing method that made it possible for a relatively inexpensive magazine like *Vogue* to publish good photographs in a way that brought out all the subtleties of the original prints. When Condé Nast saw the Baron's photographs, he was enthusiastic and ensured his services to *Vogue* with the most generous contract yet offered to a photographer. At the same time, *Vanity Fair,* a sister journal under the same editorial direction, allotted de Meyer two pages each month for the portrait of some current luminary—an actress or society woman. *Vanity Fair*'s public was much the same as that of *Vogue,* but more snobbish. Both magazines had color covers designed by such artists as Lepape, Iribe, and Marty.

As soon as de Meyer was hired as staff photographer, *Vogue* and *Vanity Fair* launched the couple in dithyrambic articles explaining to the Americans how lucky they were to have Adolf and Olga, these phoenixes, making their nest on this barbaric shore.

Emily M. Burbank, in *Vanity Fair,* wrote: "They are essentially un-American products, opposed by nature to everything we Americans deem established and conventional. They are patrons of the arts; they are artists by nature and practice: and they are romantic, not to say exotic, figures in the social life of half a dozen countries abroad. They are distinctly what in France are termed *originales,* and someone has said of them that 'they are posters for the latest whims of fashion.' If this be true, they are posters for fashions distinctly European and remote; hardly for those in prosaic New York. The chief characteristic of the de Meyers is an understanding of beauty; a reverent worship of it: an instinctive rejection of everything not beautiful." Illustrating the article was a photo showing Baroness de Meyer in profile, arranging flowers.

Later, in *Vogue* we read: "When the war came, Baron de Meyer, like so many others, found it necessary to turn his talents to commercial advantage, and so came to America. Since his arrival in this country seven years ago he has successfully built up three separate business enterprises. Besides being a photographer, he is an interior decorator and a designer and maker of women's clothes. Characteristically, he does not model his dresses on the current fashions. They are for the most part adaptations of the costumes worn in past ages. One recognizes as their inspiration the splendid garments of the Italian Renaissance, the amusing lines of a Directoire coat, or the flowing grace of Chinese robes. From a hundred sources de Meyer will draw his conceptions, but the results are absolutely his own, stamped with his own taste, and all

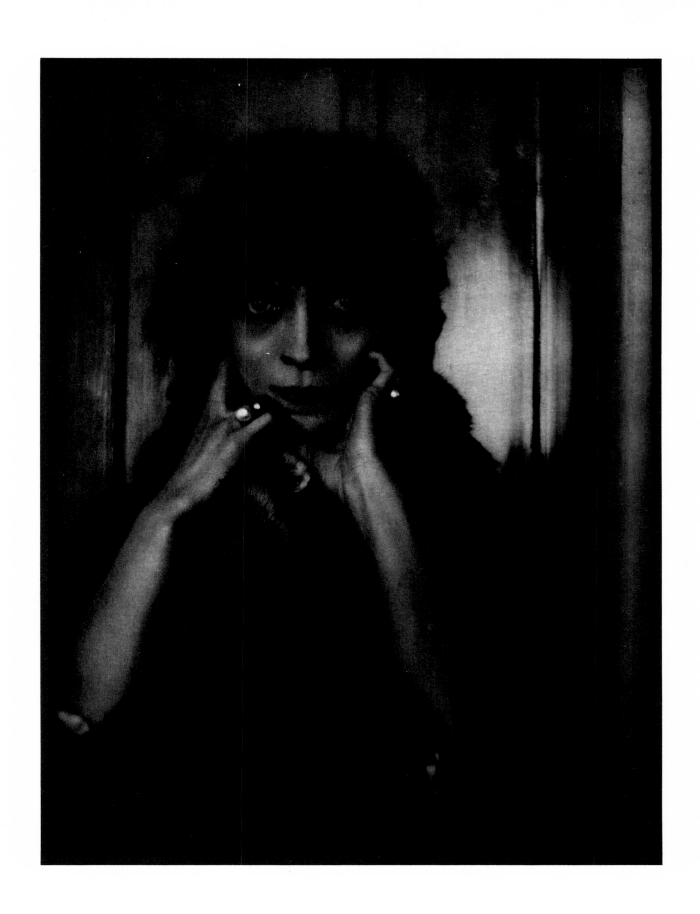

touched in some way with that fantastic exaggeration which is part of his genius." The author of this article, John Savage (perhaps it was a pseudonym of the Baron—charity does begin at home), goes on to compare de Meyer's creations with those of Bakst and Poiret. The Baron's interiors utilized a multitude of cushions of all shapes and sizes, with something of Persian splendor and Florentine elegance.

For a time, the couple managed a cabaret called The Persian Garden. With their genius for promotion, the de Meyers rapidly made a place for themselves. Adolf became positively a professor of beauty. Like Robert de Montesquiou ten years earlier, but with greater success, de Meyer gave drawing-room lectures that served as a sort of belated finishing school for women who were very rich but not very sure of themselves. He was concerned with every aspect of gracious living: flower arrangements, the placing of guests at table, the choice of a carpet or of a butler. It is to him or to one of his pupils that is attributed the remark: "One of the most difficult things in life is to find an intelligent second footman." One of the most famous of his "beauty lessons" was a picture-evening at Mrs. W. K. Vanderbilt's, where the prettiest women posed as Botticellis, Giorgiones, or Titians in costumes copied in minutest detail. Soon it was being said that de Meyer himself was the new Titian or the new Van Dyck.

It is worth noting the extreme professionalism that lay behind this dedication to beauty and transformed it into something substantial. Robert Brandau describes the de Meyer hallmark as "a mystifying and flattering technique of lighting, placed with skill and conveying a radiance and sparkle that enveloped the subject and almost blinded the lens. His usual camera was an 8×10 model fitted with a ground-glass back and an English lens made by Pinkerton-Smith, a London optical firm specializing in equipment for the Royal Navy. He had purchased it in 1903. Ground to pinpoint sharpness in the center and falling off around the edges to produce softness of focus, the lens—in combination with the type of emulsion used to coat photographic plates at that period, and the stretched gauze often employed to diffuse light—helped de Meyer create the prints he is famous for. 'As I have always said,' he wrote Stieglitz, 'what I can't do with the old Smith lens I won't touch. Pinkerton-Smith owes me quite some advertising.' "

In America Adolf de Meyer's scope stretched far wider than mere fashion. He was the arbiter of taste and manners, the most valued advisor in all that concerned society, the theater, or decoration. Soon it became a certificate of elegance for a Newport aristocrat or a Broadway star to have her portrait, signed by de Meyer, in *Vogue*. Through his art, brides were transformed into Isoldes weighed down with arum lilies; singers appeared as Gainsboroughs, all in lace and rose pompoms. The Baron gave them all that aura of elegance bestowed by English *chic*, Slavic charm, and Parisian dressmakers. Mrs. Howard Cushing, Dorothy Gish, the divine Lady Ribblesdale (once Mrs. John Jacob Astor), and Margaret Lawrence were his models; and through him all became part of the marvelous, vanished world of Edwardian balls and the Russian Ballet. Some vaguely resembled Lady de Grey, some Anna Pavlova; others with more personality, such as the dancer Irene Castle, presented an image of very modern *chic*, or, as Jeanne Eagels, that sort of transparent beauty that would a few years later bring Garbo fame. The supreme skill with which the Baron made use of back-lighting created a poetic halo around the

most ordinary people. One saw just the profile, outlined by the light, against a silver background. Once he shocked an aging beauty by placing a light in her bodice, but he was forgiven when he showed her a photograph that made her look twenty years younger. On another occasion, he obtained a reflection on a dress by spilling the water from a vase of flowers onto the floor. He photographed very rich children in expensively simple clothes and made them appear uncommonly pretty, with the disquieting innocence of the children in *The Turn of the Screw*. His blurred effects were especially successful in photographs of lingerie, worn by models with the golden curls, large eyes, and tiny mouth of Mary Pickford, reposing in muslin negligees on lace-edged pillows.

One cannot help feeling that the photographer of Nijinsky must have felt a certain bitterness about descending to nightgowns, but his exquisite courtesy toward his models never failed. Some of them—they are old ladies now—recall that the Baron treated them like duchesses. They remember his prematurely white hair (which he always covered neatly with a net before placing his head under the black focusing cloth) and the Baroness, who often came to fetch him from the sittings.

Besides these photographs of fashion and society, there are issues of *Vogue* dating from the early twenties that contain very fine still lifes by de Meyer, with arrangements of flowers, crystal, or china around a lamp or on a dining room table or mantelpiece. These images give us an idea of the taste with which Adolf de Meyer had furnished his country place and of his success as an interior decorator. (Naturally, he did not have a shop and had nothing to do with tradesmen, but merely suggested color schemes and arrangements.)

It is easy to imagine Edith Wharton's heroines in a de Meyer décor—melancholy millionairesses, society women torn between the desire to keep up an appearance and the need to be loved (even by someone not quite of their class), and consoling themselves by creating a garden, collecting jade, or trying their hand at interior decoration. Elsie de Wolfe, from her house in Versailles, made capital out of this kind of taste and was soon exercising immense influence on the decoration of all the Trianons and Chambords which had sprung up in Newport or Long Island twenty years earlier. Furniture from Seligmann or pictures bought from Duveen (so that they should not seem to come from a shop) had to be expertly presented, surrounded by flowers and ornaments, in an eighteenth-century décor—French, of course, for the drawing rooms, Chippendale or Adam for the dining room, and Italian for the ballroom. The rooms had to resemble the delightful interiors painted by Walter Gay (a friend of Edith Wharton's) in French châteaux. The Baron, either in memory of the Russian Ballet or because he was attracted by the East, also had a taste for Coromandel screens, lamé cushions, glass cabinets full of jade, and Chinese cachepots overflowing with blue hydrangeas. In these circles, before jazz came into fashion, noise was muffled by thick carpets, and one heard only the yapping of a Pekingese, the grating of the wheels of a Rolls-Royce on the gravel, and occasionally the languid voice of the Baron de Meyer busy photographing the mistress of the house or a rose in a "simply divine" Capo di Monte vase. Color was as insupportable as noise. Elsie de Wolfe invented beige and, for the country, slightly faded toile de Jouy; off-white was launched by Syrie Maugham in London.

The Baron liked Whistlerish "symphonies" in silver and midnight-blue, old gold and ivory. Behind this luxurious austerity lay a terror of being thought vulgar, but it was not long before *The Great Gatsby* and jazz arrived to change all this.

Even by 1916, before his *Vogue* fame, Adolf de Meyer was earning a great deal of money. Olga had continued her pro-German propaganda in articles for the Hearst press, but that did not matter: Both were too intelligent to waste time over quarrels which were obviously outside the scope of their social or aesthetic talents. They did consider, however, that the time had come to do something about their souls. New York was beginning to be what it has since become—a sort of Alexandria where it is easy for all the religions from Asia, all the sects created by cranks or deranged minds, to find adepts. Young Ramakrishna, with his godlike beauty, was being brought up in Florida by disciples of Mme Blavatsky. There was a profusion of seers, gurus, theosophists—some inspired, some charlatans, all skilled at calming for a time the anxiety of people whose lives were dedicated to money and pleasure. The de Meyers met Nicholas Roerich, a Russian painter they had known when he was doing the décor for the *Sacre du printemps* and who was passionately interested in mysticism and Central Asian art. An astrologer gained great influence over the couple and gave them new names which their horoscopes indicated as being beneficent: Olga became Mhahra and Adolf, Gayne; from then on, they were known by these names, even as they began their public career in *Vogue* and *Vanity Fair*.

From 1916, they lived in a house at 18 East 54th Street, which they called Gayne House. It was on stationery headed with this address that the Baron wrote the following letter to his friend Stieglitz. It reveals how, when he speaks of his art, all trace of snobbishness and affectation disappears:

Feb. 12th, 1921

My dear Stieglitz,

This isn't meant for complimentary words, you know the value of your work as well as I do, you need not be told.

This is just to say your work has produced a big impression on me. I forgot photography, just felt your mind expressed in your own medium. Though I know your mind is big, it is fine to have been able to express it, so we can see it and understand it better. I wish you were again influencing us all or at least one or two, myself included. Stimulus is needed and there is no one to stimulate. Your lofty ideals even if too high for my own commercial use, could not help being felt, and would hinder one to deteriorate beyond recall!

Commercially, I claim to be the finest photographer in the world, even if only as a much needed bluff, but what photography means is only brought back to my mind on just such an occasion as my visit to the Anderson Gallery. Thank you for reminding me of it.

Yours in sincere friendship and grateful thoughts of years gone by.

Gayne de Meyer

The Armistice had hardly been signed before the de Meyers were back in Paris. Olga-Mhahra was more elegant than ever, extremely slender, with a sort of authority in her manner resulting from *chic* as well as from metaphysics. She was one of the first women to cut her hair and rinse it blue; then she was brave enough to adopt short gray locks, framing a face which had remained surprisingly young. Adolf-Gayne was now rather portly—a personage in the Diaghilev style, complete with fur-lined overcoat, monocle, cane, and Fabergé cigarette case. "Really, there's no place like Paris," cried Olga, as she embraced her old friend Jacques-Émile Blanche in the lounge of the Ritz. The Baron made a round of the couturiers, spotted talented newcomers like Lanvin and Molyneux, and sent marvelous photographs to *Vogue.* Condé Nast published them with all the proper pomp and circumstance in a sort of album, in which the Baron paid homage to the masterpieces of the couturiers, just as he had once done to Diaghilev. Each of them was revealed here in his own particular style—the *jeune fille* quality of Jeanne Lanvin's work, Poiret's orientalism, the splendor of Jenny's huge mantles, and Worth's jewel-encrusted gowns. The Baron had a weakness for the creations of Lucile. This was the pseudonym adopted by a highly eccentric Englishwoman, Lady Duff-Gordon, sister of Elinor Glyn. Lucile's theatrical, sensuous dresses seemed made for the heroines of the inventor of "It." Certain photographs, very much in the style of *À l'Ombre des jeunes filles en fleurs,* were taken in formal gardens or in orchards; others à la Guermantes, in mansions in the faubourg Saint-Germain; but the details were never too explicit and the atmosphere was created by light and a sense of space.

Waists were still in their proper place in the year 1921, but dresses were getting shorter; hair was still done up in a bun; wide hats, edged with lace and bristling with aigrettes, were in fashion, as were scarves, trains held by heavy jewels, and feather fans. Tiaras were worn low on the forehead; the couturiers realized ideas invented ten years earlier by the Marchesa Casati, so that she was forced into ever greater eccentricities. De Meyer published (in *Vogue,* as usual) several photographs of the actress Cécile Sorel, a regal beauty, along with interior shots of her house, which was provided by her lover, the architect Whitney Warren, and was reminiscent of Versailles. This taste for splendor after wartime austerity came partly from the Russian émigrés, some of whom became designers, while others were mannequins.

The Baron's descriptions of the gowns, forwarded to *Vogue,* might have been penned by Ronald Firbank: "a hat of Italian straw, draped with cream-coloured lace held back by yellow peaches . . . a gown of pale yellow organdie decorated with curious tufts of monkey-fur . . . silk mantles, decorated with exquisite furs, incoherent for a summer fashion. . . ." One can imagine how the Baron would have photographed Lady Parvula de Panzoust, the Duchess of Varna, and even Cardinal Pirelli. Firbank's very titles sum up the life of the de Meyers: *Vainglory, Caprice, Inclinations.*

The Baron played a part in one very Firbankian story. One day Sir Robert Abdy, a famous dandy, escorted his friend Emerald Cunard to a fashion show at Callot's. Among the models he noticed a very beautiful Russian girl and said calmly to Lady Cunard, "That one will be my wife." "You must be out of your mind. She would never be distinguished enough, and you would be made to look ridiculous." "I bet you two thousand pounds that within a year Lady

Abdy will be the most elegant woman in Paris or London." The young woman quickly accepted his proposal, and Sir Robert went to the Baron de Meyer, saying, "Here are two thousand pounds. I count on you to launch Iya." Shortly after, marvelous photographs were appearing in *Vogue;* the young woman, wearing fabulous gowns, shone at the most elegant balls and first nights . . . and Lady Cunard lost her bet.

The de Meyers were determined to resume their old life-style. They rented a fine apartment in a grand house in the faubourg Saint-Germain, where they entertained constantly. They were fêted by everyone, except the Princesse de Polignac, who spread the most appalling rumors about them and said, "Filthy Krauts," in a stage whisper whenever she came across them. They became especially friendly with Étienne de Beaumont and appeared at his balls in magnificent costumes. Comte Étienne de Beaumont was one of the most brilliant representatives of the intelligent "society of leisure." He had money (but not a great deal of it—just enough to keep up a very fine property) and taste (an immense amount of this—he even designed trinkets for Chanel) as well as an aristocratic tradition of hospitality and a certain insolence. Before giving a ball, he would carefully draw up a list of the people he did not intend to invite, and who consequently would be ill with frustration. But he always invited artists (he was a great friend of Picasso and Marie Laurencin), musicians (the group *Les Six* gave their first concerts in his beautiful mansion), and such writers as Cocteau, Paul Morand, and Anna de Noailles, who were among his close friends. Étienne de Beaumont had known Proust only slightly but claimed to have been the model for Robert de Saint-Loup; he was above all the model for the Comte d'Orgel in Radiguet's novel *Le Bal du comte d'Orgel.* In 1924, he organized *Les Soirées de Paris,* at which a number of important stage works were performed in a Montmartre music hall called La Cigale. They included Cocteau's adaptation of *Romeo and Juliet,* with décor by Jean Hugo, and ballets with music by Milhaud and Poulenc and with décors by Derain and Braque. The Comte de Beaumont, tall, with a piercing voice, presided over all these events.

Like Gayne de Meyer, Étienne de Beaumont was married to a wife who was an admirable assistant. Soon the de Beaumonts found the couple to be indispensable. There was a great fancy-dress ball each spring, and the de Meyers always came in the most sensational costumes: Once, Mhahra had a great success as a silver rose, in a costume streaming with silver beads in the style of Erté, with silver flounces turned up to show her perfect legs. But there was some surprise when they turned up in a Surrealist interpretation of *La Dame aux camélias;* Mhahra's dress suit set tongues wagging, as did Gayne's cape and spangled top hat. They were applauded, however, when they came as Spaniards, accompanied by Mme Errazuriz and Picasso.

It had been a joy too to meet Misia Edwards again. She was now married to José-Maria Sert, and through her they became friendly with Chanel. Misia had an enormous apartment on the quai Voltaire, and Chanel had an equally impressive one in the faubourg Saint-Honoré. There was constant coming and going between them, punctuated with fêtes, quarrels, and enthusiasms. *Couture* brought in money for performances of the avant-garde works of Cocteau, Diaghilev, and Stravinsky. In Paris or in Venice, one led the same life, went to the same parties. It was marvelous and exhausting. Misia took stimulants to keep herself going;

One of a series of photographs for Elizabeth Arden cosmetics advertisements

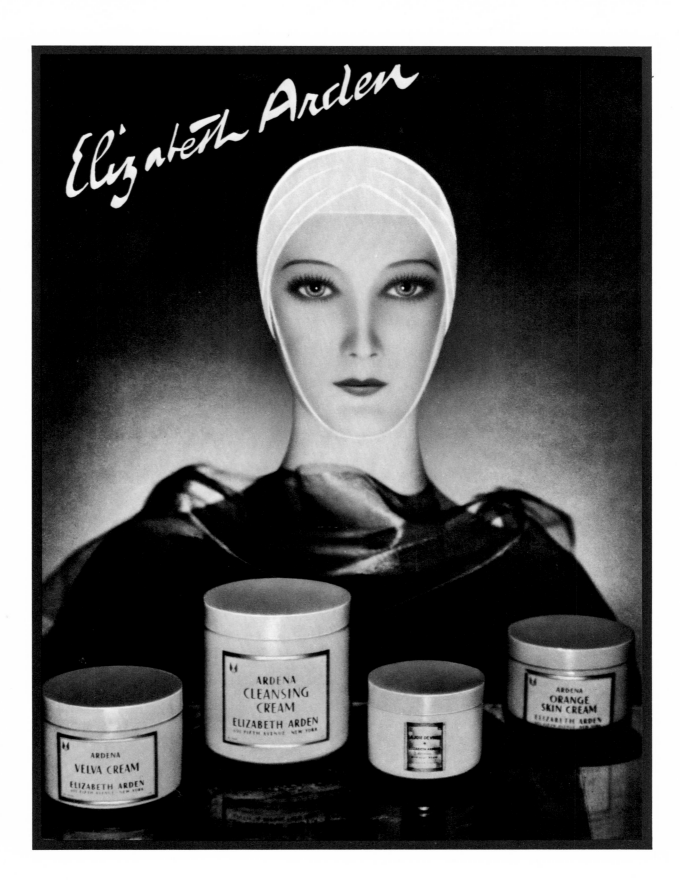

Cocteau had recourse to opium. The Russians drowned the memory of their misfortunes in various drugs and created havoc between even the most devoted couples.

The de Meyers became especially friendly with Princesse Eugène Murat, an eccentric who managed to be excessively elegant in spite of her elephantine proportions. Never had anyone such a thirst for pleasure as had this woman, who appears in *Le Bal du comte d'Orgel* under the name of Princesse d'Austerlitz. She lived to the rhythm of Scott Fitzgerald. Not a day could pass without something happening—a fête, the discovery of some *apache* dance hall, a surprise party to scandalize some respectable château-owner. Violette Murat was the first Frenchwoman to drink whiskey and attend boxing matches. She owned a yacht and often invited Gayne and Mhahra de Meyer for a cruise. She was the first to have the idea of spending the summer on the Riviera. In Toulon, she was to be seen in the sailors' dives, arm in arm with the Baron, both dressed as fishermen. When in New York, she spent most of her time in Harlem.

It was Diaghilev, though, who remained the incomparable friend, the true creator of beauty. Each year, the de Meyers joined him in Venice, where they continued to rent the Palazzo Balbi-Valier. There they would be sure to find Misia Sert and Coco Chanel, various Austrian princesses in love with Rilke, and Italian princesses enamored of Mussolini. Yet the old aesthetic atmosphere had lost its prestige. Cole Porter reigned in place of D'Annunzio, and a dreadful little woman, jovial and overfamiliar, named Elsa Maxwell, organized burlesque parties in order (Cecil Beaton tells us) to make her distinguished guests look as common as herself.

One year, Gayne and Mhahra made a voyage to India, and on the way back their search for truth led them to Egypt, where the Alexandrian dandy Felix Rollo became their guide. There was also a visit to Hammamet, in Tunisia, where they stayed with their friend Georges Sèbastian, a Rumanian who had made a rich marriage and was building a palace right out of the Thousand and One Nights. Metaphysics, however, could never compete with their passion for society life, and the de Meyers were no sooner back in Europe before the round of balls, dances, and galas began again.

Twice a year, Gayne visited New York, and he was soon in the habit of spending the winter months at Palm Beach, where the atmosphere of luxury appealed to him and he found millionaires to pose for him. He spent a season in Hollywood, but he was not understood there and his fine manners made no impression.

In 1923 he allowed himself to be tempted by the golden promises of *Harper's Bazaar,* one of the Hearst journals, and *Vogue*'s great rival. He was offered, and accepted, a twelve-year contract at three times his former salary, prompting the British edition of the *Bazaar* to run an advertisement (with type superimposed upon a tasteful spray of roses photographed by the Baron) proudly proclaiming: "Baron de Meyer is the greatest fashion photographer the world has yet seen, and his photographs and dress reviews appear *exclusively* in 'Harper's Bazaar.' This alone makes 'Harper's Bazaar' unique. . . ." Now impressively matured, de Meyer's work appeared month after month through the twenties and on into the thirties. The professional model system, nonexistent when he began, brought him new flexibility; his own contributions included the introduction for the first time of a male model as a background foil, and the use in some

pictures of two or more models. The lines of the photographs grew somewhat harder, reflecting the new design forms and graphics of the era. Yet the distinctive de Meyer style—the silvery prints, the skillful retouching done directly on the negative (usually the work of his brilliant, French darkroom technician and assistant André Gremela)—was unmistakable, even without the bold signature that invariably marked the corner of each picture.

Gradually, as the grim thirties approached, it became apparent that leaving *Vogue* had been a mistake. The Baron had made no radical changes in his photographic technique, and the aesthetic, aristocratic world of his art was increasingly passé. The work of the young photographers who replaced him at *Vogue*—though they owed him much—was sharper; it served *couture* first, not beauty, and made use from time to time of effects borrowed from Surrealism. There is an abyss between the worlds of de Meyer and Man Ray.

The de Meyers had not taken up Surrealism and probably found its manifestations in bad taste, but their unerring sense of beauty led them to Salzburg when Max Reinhardt organized his first festival. He was not Diaghilev, but it was very beautiful all the same, and it soon became very fashionable. The Venetian set gathered in August in Mozart's hometown. Entertainments were organized in the rococo Schloss Mirabelle, and Café Society mingled with the vestiges of the Hapsburg Empire to imagine themselves reliving *Rosenkavalier*. One met Lady Diana Cooper, Marie-Laure de Noailles, Marie-Blanche de Polignac, Chanel, but not (thank goodness) that awful Maxwell. The de Meyers were close friends of the Eugène de Rothschilds of Vienna, who were the most elegant couple in Europe, and the Baron took marvelous photos of Kitty de Rothschild. The young Tyrolean boys too were very attractive.

Youth was the fashion, and the de Meyers, by now well over fifty, became madly young. This rhythm was exhausting for people of their age, and there was more and more recourse to stimulants to procure the illusion of vanished youth. Opium had become fashionable in the early twenties, and cocaine was an amusing novelty, while the ether and morphia discovered during the nineties were considered in very bad taste. Perhaps drugs helped the de Meyers to rediscover spiritual aspirations forgotten in the course of their hectic life. Wherever they went, there would be an atmosphere reminiscent of an Oriental smoking den—Chinese carpets, low lacquer tables, divans laden with cushions, and, of course, large Coromandel screens with their processions that prepare the imagination for distant voyages. They smoked with Misia, with Tony de Gandarillas, with the musicians and dancers of Diaghilev's troupe. Here was an oasis in a frenzied world, here was elegance in a sublimated form.

The de Meyers continued to attract attention when they made their entry into the dining rooms of the Ritzes or the Carltons: "What style!" . . . Yet people who had not been "out" before 1914 would ask, "Who are they?" as one might of some half-forgotten actress whose name it is embarrassing not to know. Those familiar with society for many years still admired Olga's *chic*. She remained slim and upright, her nose a little more pointed, her eyes a little more piercing, indeed beautiful enough to serve as a model for her husband. Photos of the Baroness published in *Harper's Bazaar* around 1928 show her as the image of style, in a cloche

hat by Caroline Reboux, her profile perfect, a white streak in her hair, a necklace of huge pearls, and a black dress—the very ideal, in fact, of the personage who was becoming typical of Café Society: the bisexual grandmother.

Spirituality, alas, had little chance against Society, and both were little more than shields behind which the de Meyers cultivated their drug addiction. They received a great many guests during these errant years spent in great houses and luxury hotels, and they were becoming less and less discriminating in the choice of their acquaintances. The trouble with the pleasures which other people call vice is that they bring one into contact with individuals one would never admit to one's home if they did not share or procure these pleasures. Nervous, drugged, surrounded by ambiguous friends and accompanied by a too-conspicuous husband, Olga had become frankly spiteful. Her scandal-mongering had eliminated the last of her respectable friends, and people visited her only because they could be sure to find a pipe of opium or a sniff of cocaine. She managed never to let herself go, of course, and remained to her last day as stylish as might be expected of someone whom, as a child, the Prince of Wales had dandled upon his knees. Yet, the de Meyers' lives became hazy. It no longer mattered whether they were in Venice or in Cannes. They were invited to country or seaside mansions (which Somerset Maugham so often used as background for his stories) by people who, like themselves, had a somewhat doubtful past.

One hostess was Maxine Elliott, an actress and beauty who was doing her best to become a society woman in her old age. Her friends were English, all either very rich or very well-born or very amusing, but never all three at once. One of them was Brian Howard, a young man whose origins were rather like those of the Baron and whom they found disquieting because of the insolence with which he created every kind of scandal. (Evelyn Waugh made use of Howard for his Ambrose Silk.) They came across Cocteau, who was dividing his time between opium, sailors, and literature at the Hotel Welcome in Villefranche, and Romaine Brooks, who was sharing a house with Natalie Barney. This bohemian life did not suit them. At the age of fifty-nine, Olga died of a heart attack in an Austrian hospital where she was said to have been taking a detoxification cure.

The Baron was inconsolable. They had shared so many successes, so many reverses, so many enthusiasms and caprices, so many of those things which, after all, are bonds which tie a couple more closely than any mere sexual affinity or fidelity can do. Gayne followed the instructions of his guru by having Mhahra cremated and the ashes deposited in an alabaster urn brought from Egypt. About 1932, Diana Vreeland saw this urn by chance in an elegant apartment, all done up in white (probably by the Baron), belonging to a young German actor. De Meyer sought to console himself by communicating with his wife's spirit, and we must suppose he succeeded, for he would often retire early after dinner, saying, as he kissed his friends good-bye, "Mhahra is waiting for me," and later repeating messages from her. Unfortunately, her advice was not as good once she was dead as it had been when she was alive.

The Baron's career as a photographer was on the wane. He realized now that he had made a mistake in leaving *Vogue* for *Harper's Bazaar*, for the Hearst press had been hit by

the Depression and was economizing. He found himself bluntly dismissed, and none of his photographs appeared there after 1934. He begged his old friend Edna Woolman Chase to take him back on *Vogue,* but, as she recounts in *Always in Vogue:*

"I felt shocked and a little sad. He seemed wasted somehow and his gray hair, which had given him an elegant air, was dyed bright blue. We didn't take him back, but it was not because of spite or a desire to get even. His place had been filled and we didn't want anyone who, despite the fact that he had once been one of our big stars, was now known as a *Bazaar* personality. Also his work was sadly passé. . . . His conversation became garrulous and tiresome. . . ." The Baron produced just as regrettable an effect when he accepted an invitation from his young admirer Cecil Beaton:

"De Meyer drove down the precipitous path to my small remote house in the Wiltshire Downs in an enormous open racing car which was painted bright blue. At his approach, stones, little lumps of chalk, and rabbits scattered in all directions. Inside the car, driven by a chauffeur in livery to match the motor car, sat the Baron de Meyer, a tall, ageless-looking man in a bright blue suit and beret, with hair dyed to match. . . . He took refuge in a dreadful affectation and artifice, talking with raised eyebrows and a plum in his mouth, in a high-pitched voice that was like a stage caricature. Each word that he spoke seemed more unfortunate than the last. He giggled nervously. . . . To talk about photography, I realised, was unpardonable. It was just as much of a blunder as if I had asked him whether he himself fixed his pictures in hypo."

The Baron still had enough money, however, to go on living "the incomparable life" in Venice, Salzburg, Paris, and on the Riviera, where he rented a house by the sea. In 1935, Violette Murat's yacht was cruising off the shore, with Tony de Gandarillas on board. "Violette, let's go and say hullo to poor Gayne de Meyer." "Of course, of course. . . ," agreed the kind-hearted Princesse. The Baron was strict about etiquette, so they hunted in their suitcases for clothes more or less suitable for a visit of condolence; then the enormous Princesse and the little Chilean set off in a dinghy for the house. The Baron was taking his siesta and sent word to ask the visitors to wait in the drawing room. It was very hot; the Princesse collapsed on a sofa. Tony began inspecting the ornaments. He caught sight of an urn, lifted the lid: "Violette!" In an excited whisper he called the Princesse to see the white powder: "This is where he hides it . . . how dreadfully imprudent. . . !" Quickly he sniffed up a pinch of the powder, then offered some to his friend: "Not bad . . . have a little more. . : . ."

"Wretch . . . Olga's ashes!" The Baron had just come into the room. Tony let the lid fall. Violette Murat made her visit of condolence all the same. They both swore, on returning to the yacht, to keep the secret, but the story was too good. It was not long before Violette Murat was confiding to her friends, "Really, that little Tony is hopeless. . . . I was terribly embarrassed. . . . He's so tactless. . . ." And Tony was proclaiming, "Violette really goes too far. If I hadn't been there, she would have emptied the box!"

The Baron, however, had not lost his flair for spotting people who would have a great future, nor the art of keeping in favor with them. He was the first to celebrate Wallis Simpson, and they met again in the summer of 1938, probably at the Eugène de Rothschilds'

home in the Tyrol. He took a great many photos of her; they do not look like work by de Meyer. Elegant, of course; but neat and sharp, with no charm. And he was naturally asked to photograph the Duke of Windsor as well. One wonders whether the former Edward VIII treated him as an old friend of the family.

De Meyer lived chiefly in Paris, but whenever possible he returned to Salzburg, where he found artistically inclined princesses and accommodating boys; or to Venice, where he was sure to meet Misia Sert and Coco Chanel, as well as the old Princesse de Polignac, who hated him as much as ever and continued to remark, "Filthy Kraut," when their gondolas passed. He still received a good many invitations to the Riviera, and it was there, in Lady Headfield's house, that he heard that war had broken out in September 1939. He was accompanied at the time by a charming Tyrolean, who was dreadfully bored. In Olga's day, Adolf would not have flaunted his tastes in this way, but his air of importance was such that no one passed remarks. Once more, he was obliged to cross the Atlantic and arrive penniless in New York; but he was twenty-five years older now, and no one took an interest in his art anymore.

The climate, and a few contacts in the film world, drew him to California. In Los Angeles he met two friends from the days of his splendor: Catherine d'Erlanger, who kept a bar in Hollywood—simply because it amused her, since she still had plenty of money; and the Baroness de Goldschmidt Rothschild, née Haenkel von Donnesmark, a very great lady from Berlin, who had taken refuge in the United States. He had no success in Hollywood, but managed to have enough to live on. He lived at 6738 Wedgewood Place and was seen everywhere with a handsome young Austrian whom he introduced as his son and whom he had indeed possibly adopted. At one point, he wrote a long letter to his friend Stieglitz, recalling the splendid old times (he had earned, he said, well over a million dollars) and assuring him that he meant to begin work again. He died, however, of coronary thrombosis on January 6, 1949, without having made a new career. He was cremated and buried at Forest Lawn. His death certificate gives his profession as "writer (retired)" and states that the information came from Baron Ernest de Meyer, who is listed as next of kin. This was probably the Tyrolean, since the names of the deceased's parents are given as "unknown."

It has not been easy to discover anything about the de Meyers from their friends who are still living or were alive more than twelve years ago, when I first became fascinated by the great photographer and his extraordinary wife. On the whole, comments were severe, and stories about them unfavorable. When I questioned Violet Trefusis, who had often come across them in the course of her life, she remarked, *"Très à-côté."* She had several things in common with Olga. As Mrs. Keppel's elder daughter, she encouraged the idea that Edward VII had been her father. She too had been very friendly with the Princesse de Polignac, had shone at Étienne de Beaumont's balls, and had had Tony de Gandarillas for her seventy-year-old page. Violet enjoyed puns. "I called them *Pédéraste et Médisante,* because he looked so queer and she had such a vicious tongue." It was she who told me the story of the Baroness's ashes, which was confirmed by several other people, though I never dared to mention it to Tony de Gandarillas.

The Worth salon in Paris in the mid-1930's. Baron de Meyer is at right.

Tony recalled the de Meyers as an absurd and marvelous couple who had been intimates of his aunt Mme Errazuriz and, through her, friends first with Sargent, then, for a time, with Picasso.

Much earlier, Lady de Grey's daughter, Lady Juliet Duff, who belonged to the same circle, had shown me scrapbooks with photos of de Meyer alone and of the two of them, including one taken with the handsome actor Lou Tellegen. It was in London too, quite recently, that I enquired about them of a friend whose mother had been an Edwardian hostess. "How strange you should mention the Baron de Meyer!" she wrote. "Adolf was pointed out to me on the Lido in 1926(!) and his half-brother, Louis, was a great friend and admirer of my mother. He was very good-looking and used to stay with us at my old home Kingston Lacy, and my sister and I were madly in love with him! Long before your time—in Edwardian days."

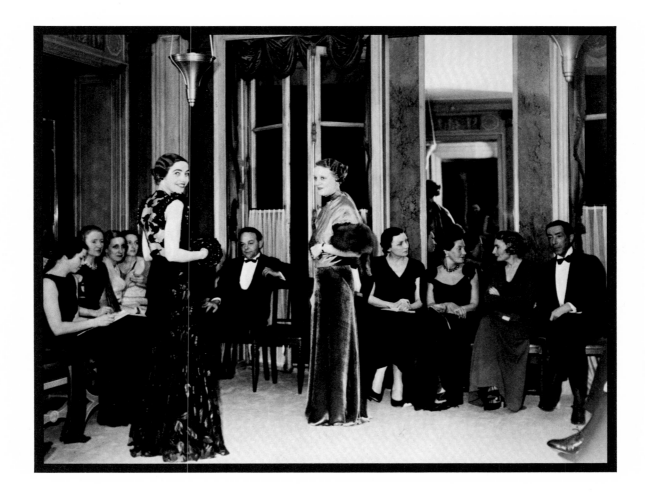

A few years ago, I happened to meet in New York an old lady who had obviously been a great beauty and had posed for the Baron when she was a model in the twenties. In Paris, an extremely elegant woman (formerly Minou de Montgommery, now the wife of Général Béthouard), remembered that as a young girl she had posed for the Baron in gowns by Vionnet: "Once, when he wanted to give an impression of the lightness of muslin, he had the idea of placing a ventilator on the floor. This slightly lifted the skirt of my dress so that I seemed to be floating, rather as one does in a dream. He was very good-looking, always impeccably turned out, even during the sittings, which were very long because he was so meticulous."

Boris Kochno had the same impression of him. He received me in his tiny house, crammed with souvenirs of the ballet, drawings by Braque, Picasso, and Bérard, from the archives of Diaghilev and Misia Sert. "He had great style—rather in the manner of Étienne de Beaumont, but more pompous. Everyone knew, of course, about the couple's tastes, but they never compromised themselves; they had beautiful manners. Diaghilev adored them; they were really close friends. . . . And what a marvelous artist he was!"

Cecil Beaton's word-portrait of the Baron, quoted earlier, might cast doubt on his *chic,* but Sir Cecil assures me that Olga remained the essence of elegance and astonishingly young-looking to the very end. A profile of her, sketched in the margin of his letter, shows her as he knew her at the end of the twenties, with her long neck, pointed nose, and thin, sinuous lips. And Beaton, who himself followed the Baron in the succession from Whistler, Sargent, and Boldini, adds: "He was a very great photographer."

I talked about the de Meyers in Marrakech with Ira Belin, a Russian who was more or less a dealer in antiques, knew everyone, and collected stray dogs. She was a niece of Stravinsky's and, though she could dance hardly or not at all, she had been allowed to appear in Diaghilev's ballets because of her supreme beauty. She told me that hers had been the face in the famous photograph by the Baron that Elizabeth Arden used for several decades to advertise her cosmetic products.

Finally, I talked about them one evening in 1974 in a street in Alexandria— that tragic city with its ruined splendor. I had become lost, and I asked my way of a man who wore his shabby clothes with a kind of studied elegance which made me suppose he might speak French. He did speak it, though with a strong Levantine accent. "So Monsieur comes from Paris! I adore Paris, though I have never been there. . . ." A closer view of this person revealed him to be extremely old. He had a thick coating of powder on his plump, flabby cheeks, and his hair may well have been a yellowish wig. "Tell me about Cocteau. . . . But he is dead? What a pity!" And he raised to heaven hands laden with rings that must have been discovered in the tombs. "Walk a few steps with me, dearest sir. . . . I come of a very ancient Armenian family. I was handsome, rich, and artistic . . . so artistic! See, here is my photo when I was twenty." Searching in a handbag among a jumble of tubes, cosmetics, a packet of Turkish delight, letters, and a powder puff, he produced an old newspaper cutting on which one could just make out the figure of a young dancer. "My début at the Winter Palace of Heliopolis. But it was impossible for a member of my family to become a dancer, and I renounced a fine career. The friend, the great photographer, who took this picture, would have given me my chance; he found me very beautiful. It was the famous Baron de Meyer, dearest sir. I met him with the Baroness Mhahra at Mena House, when they had just returned from India. That very evening, they asked me to dance for them, naked, in front of the Sphinx. There were Beduins holding torches for us. Ah, how they loved beauty. . . . I often think of them. But here is my tram. . . ." And the stout old man leapt with surprising agility into the already tightly packed vehicle. "Give my best regards to the Baron!" he cried, waving his puff, and its powder mingled with the dust in the street.

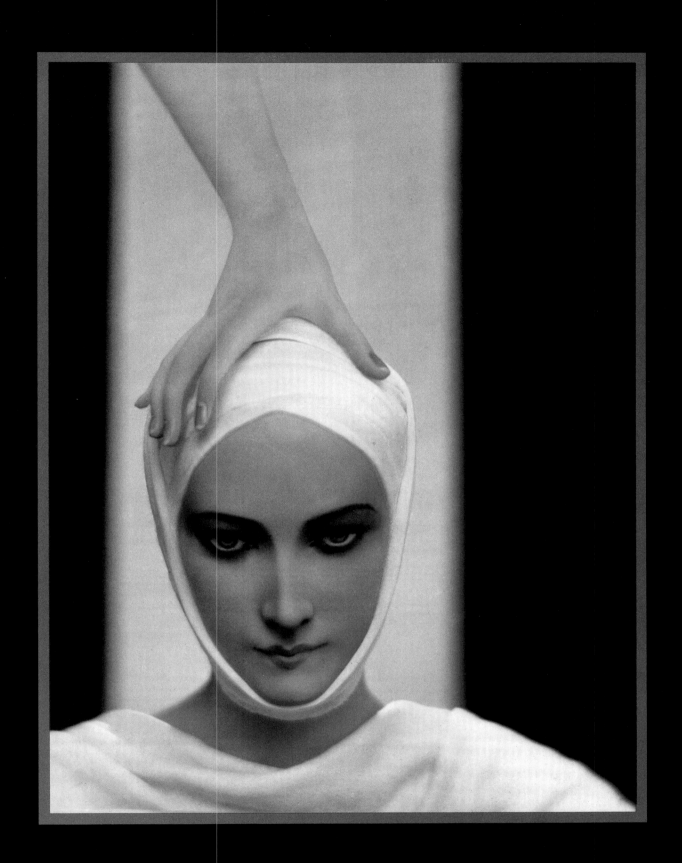

1 / Advertising photograph for Elizabeth Arden

The preceding page

2 / Still life

The preceding page

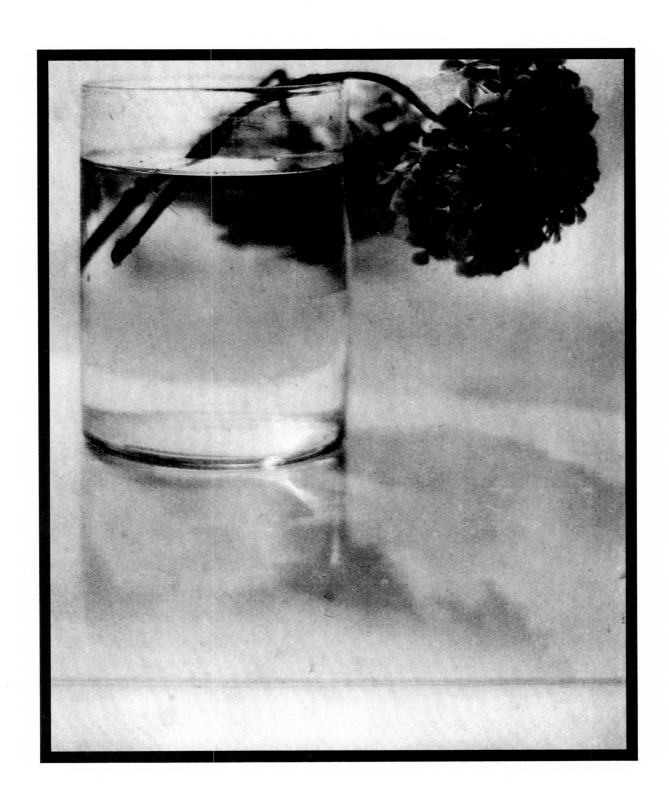

3 / Alvin Langdon Coburn

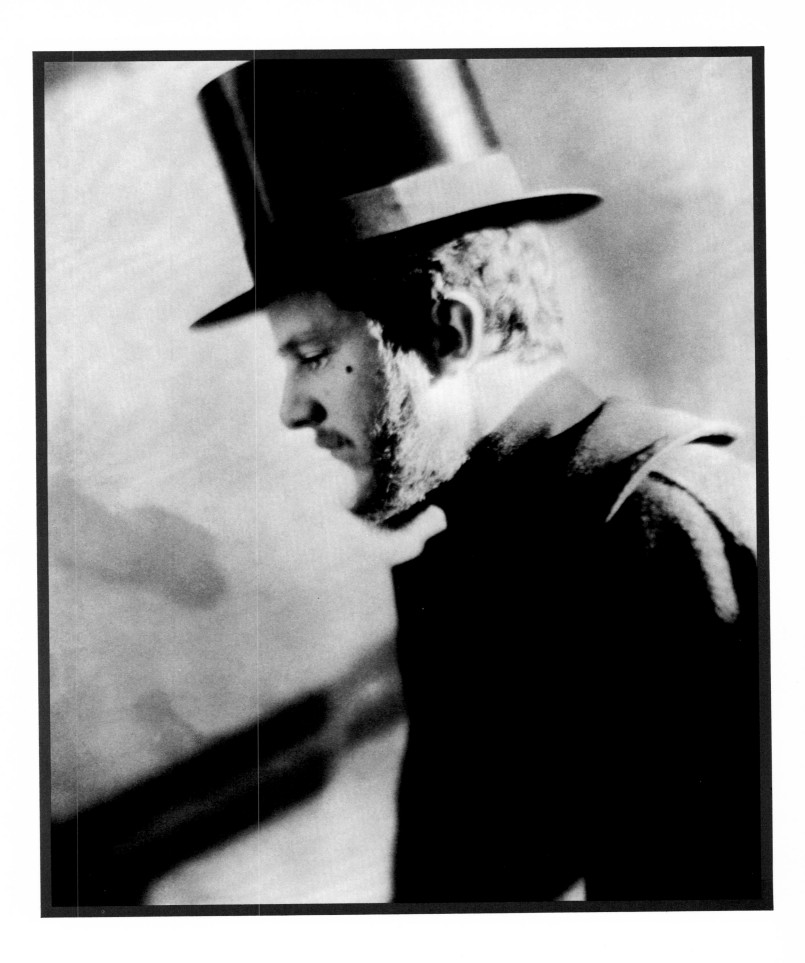

4 / Olga de Meyer

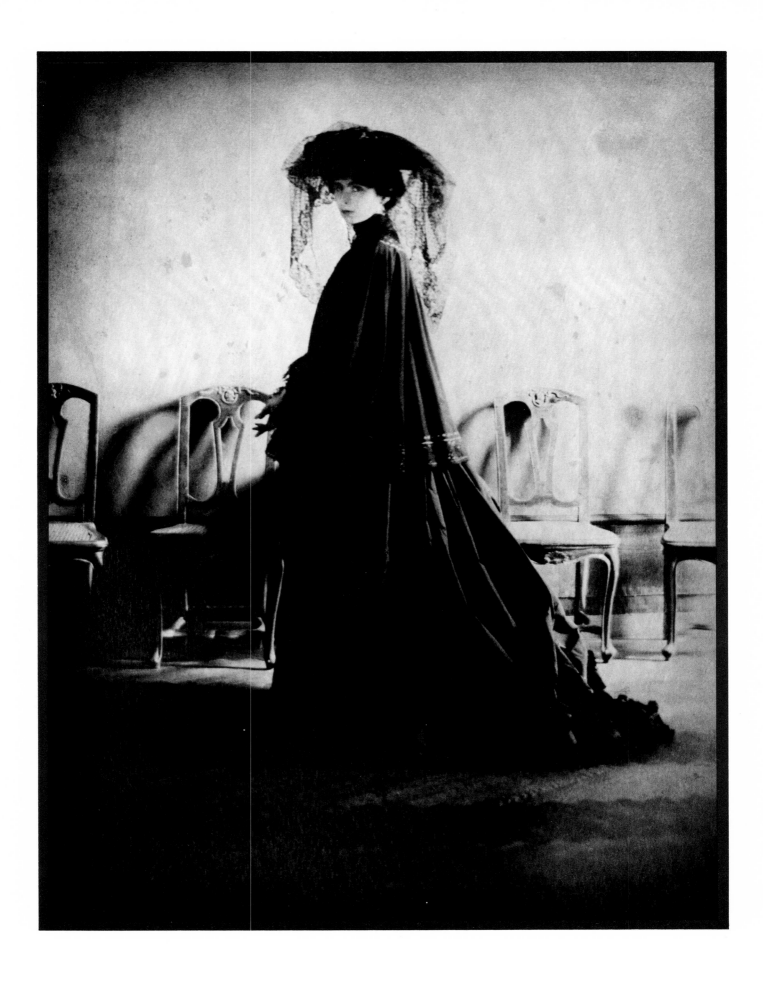

5 / Turkish child

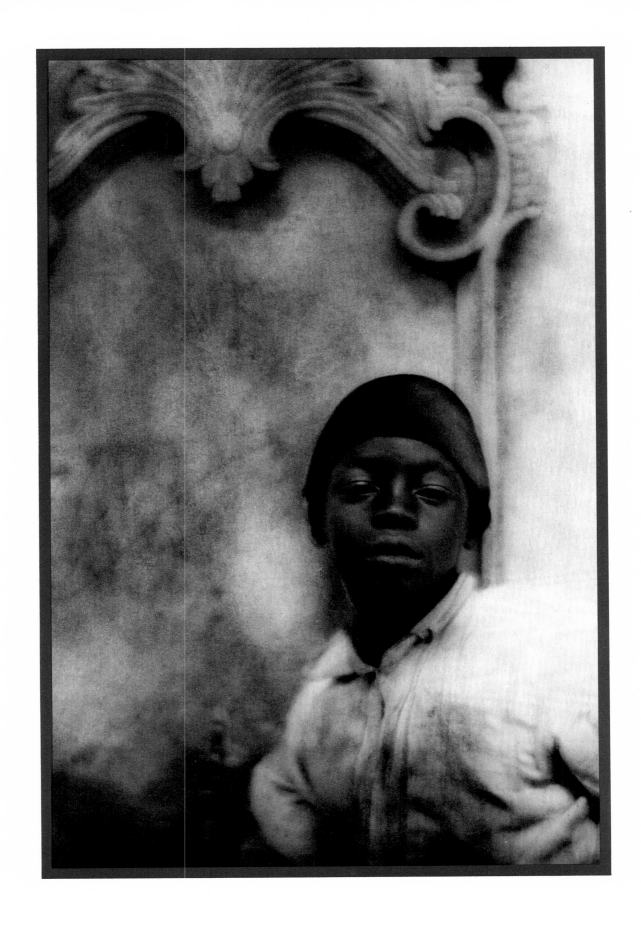

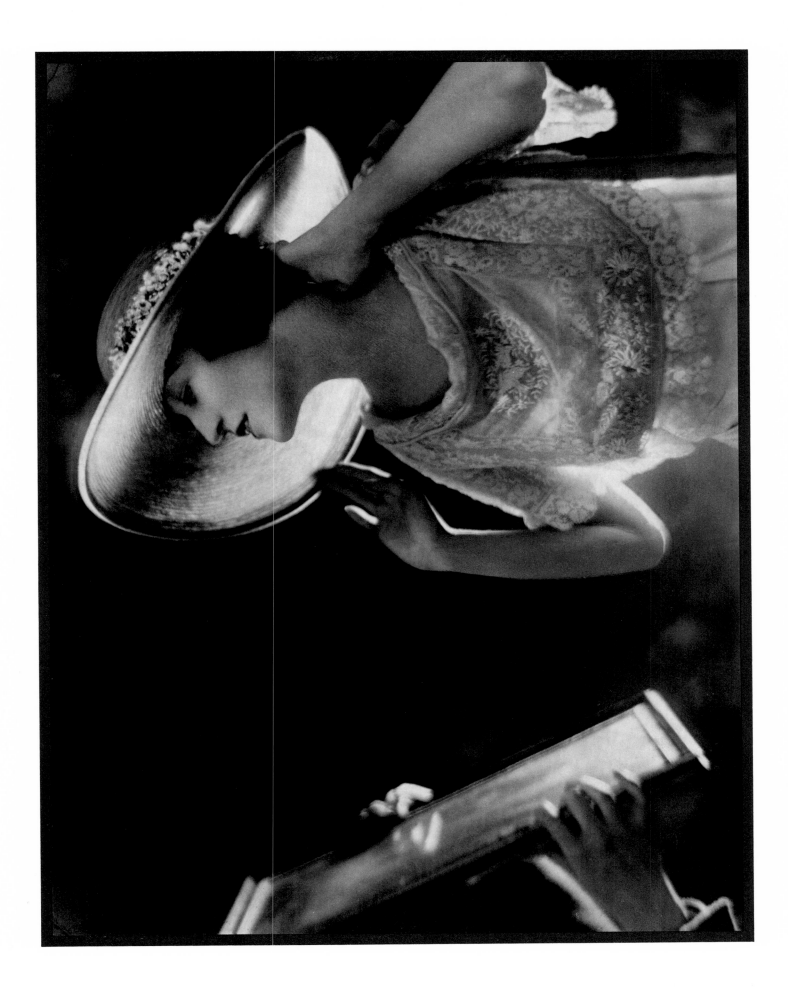

7 / Beatrice Beckley

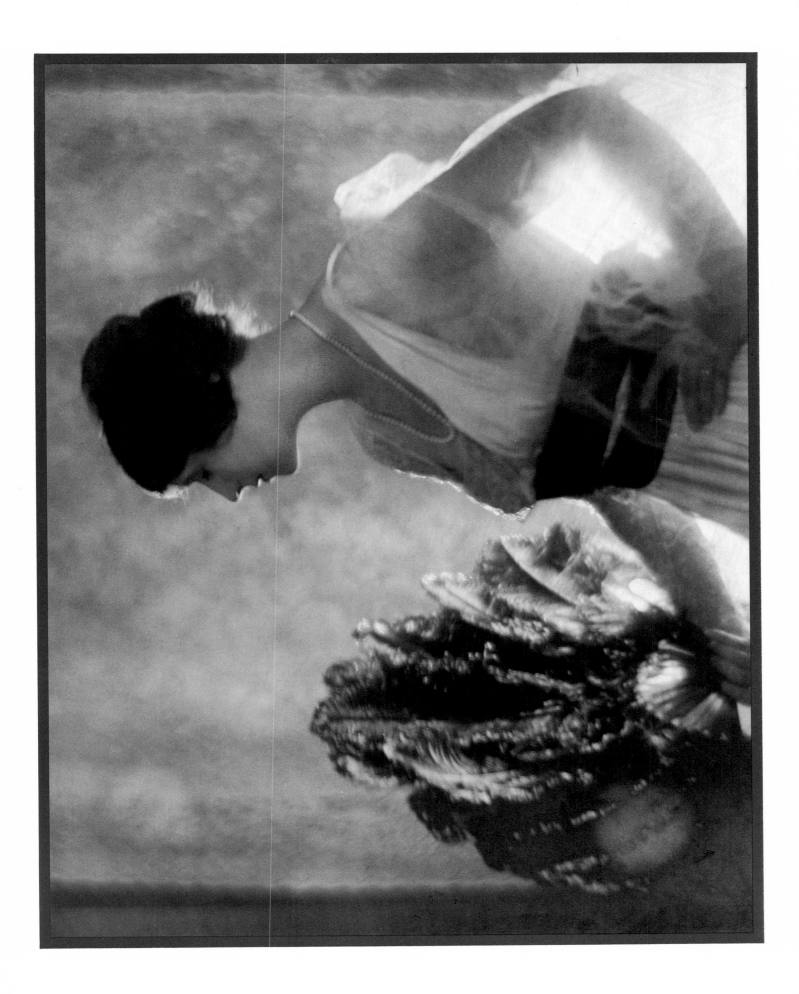

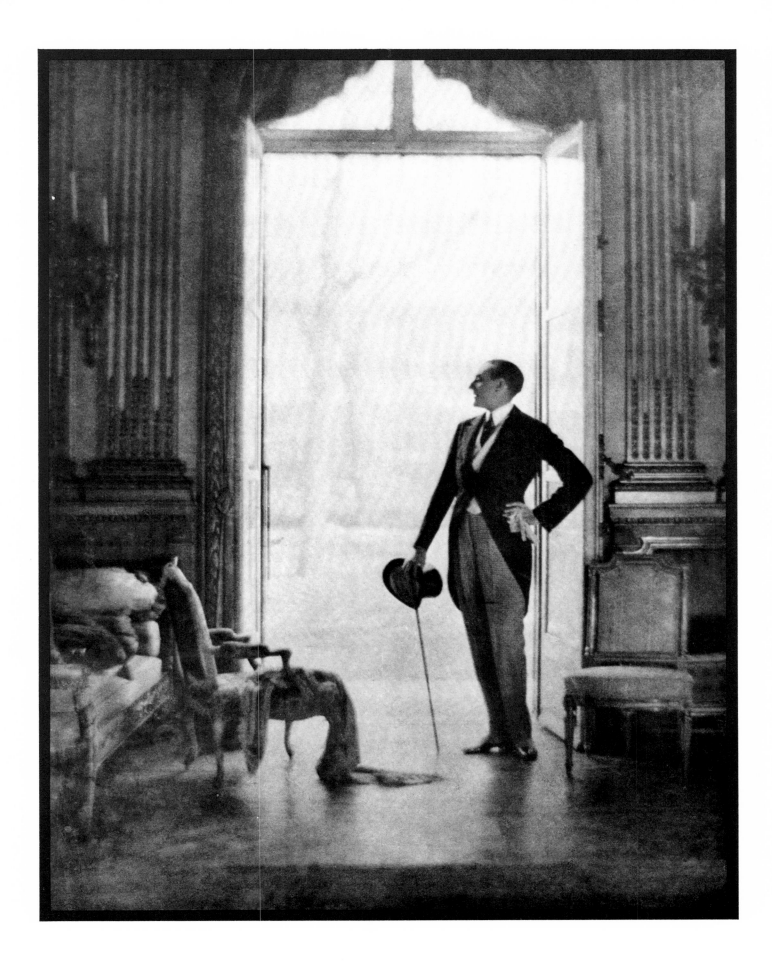

9 / Lady Ottoline Morrell

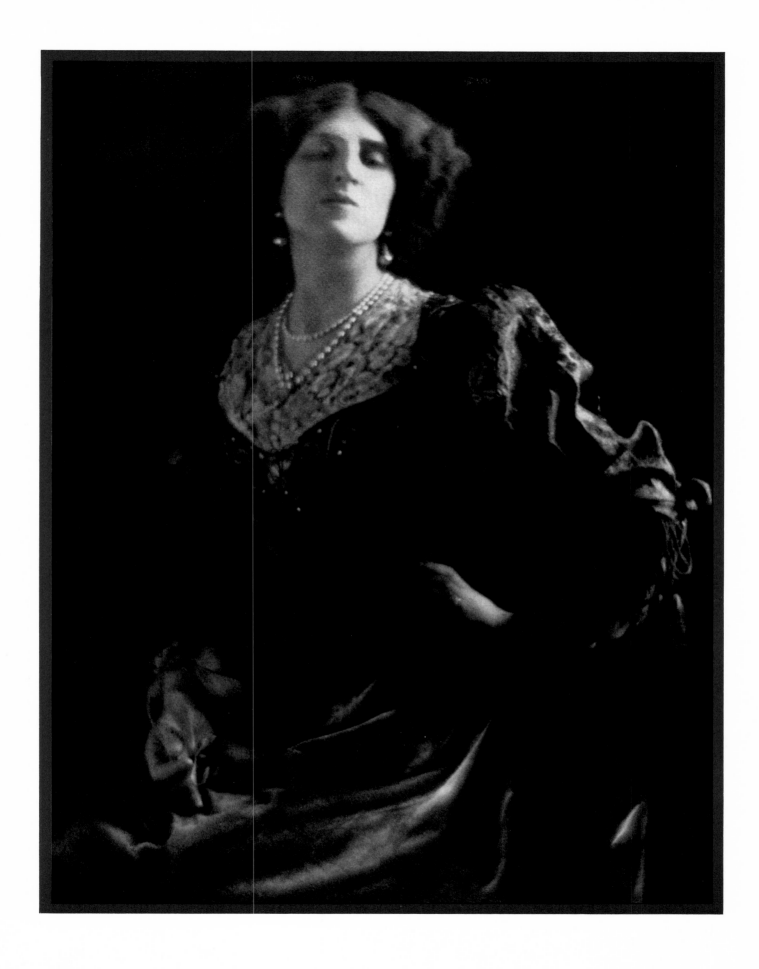

10 / Gertrude Vanderbilt Whitney

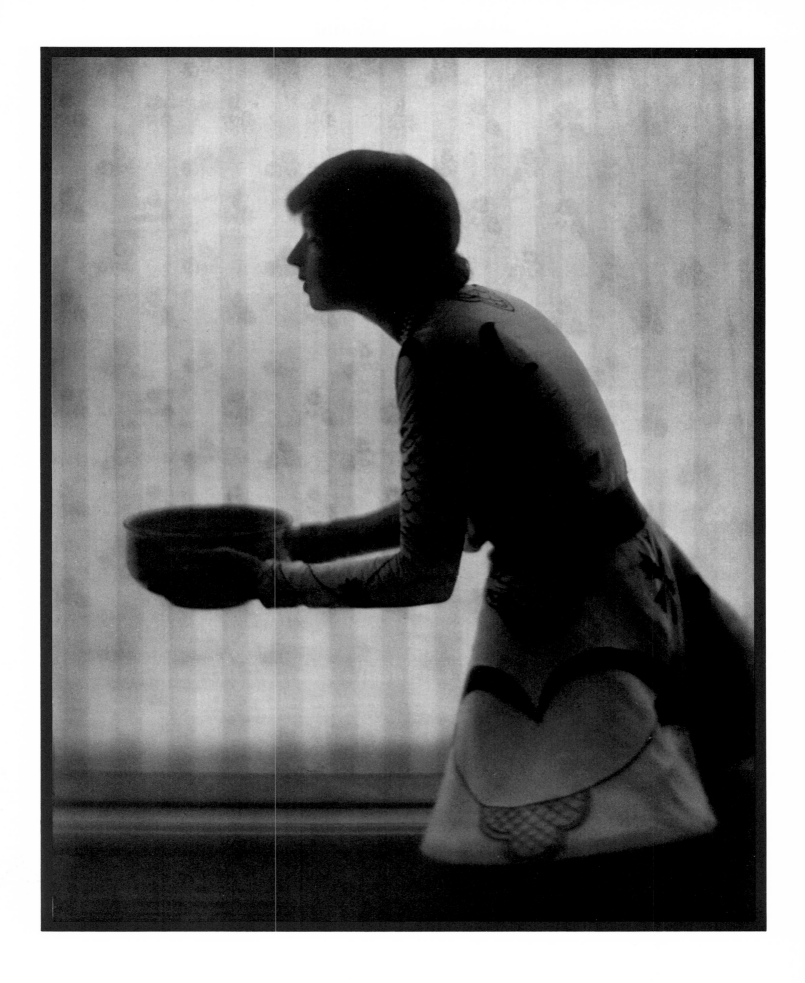

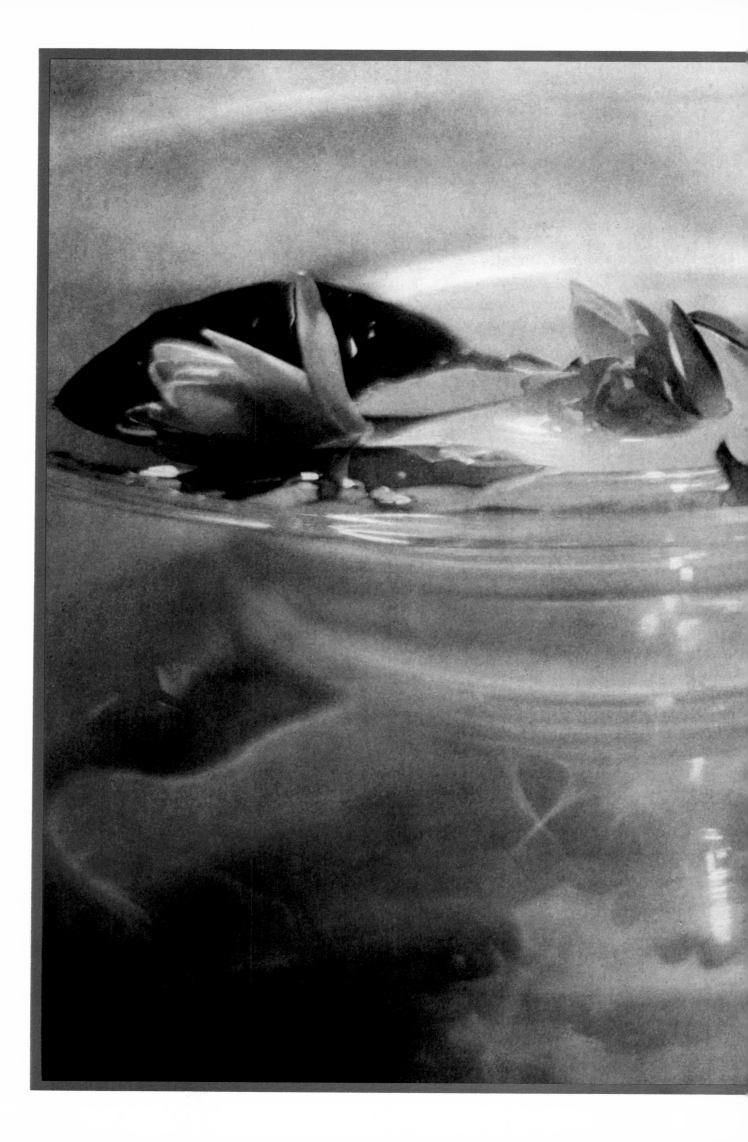

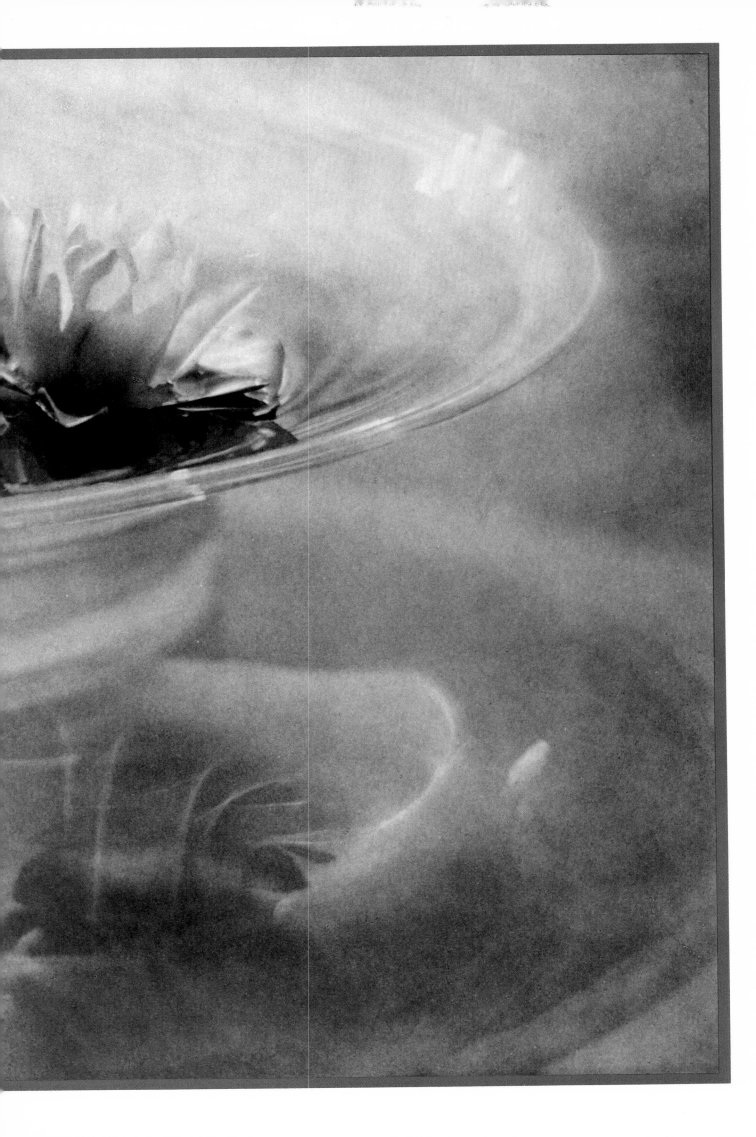

11 / Still life
The preceding pages

12 / Dorothy Smoller modeling

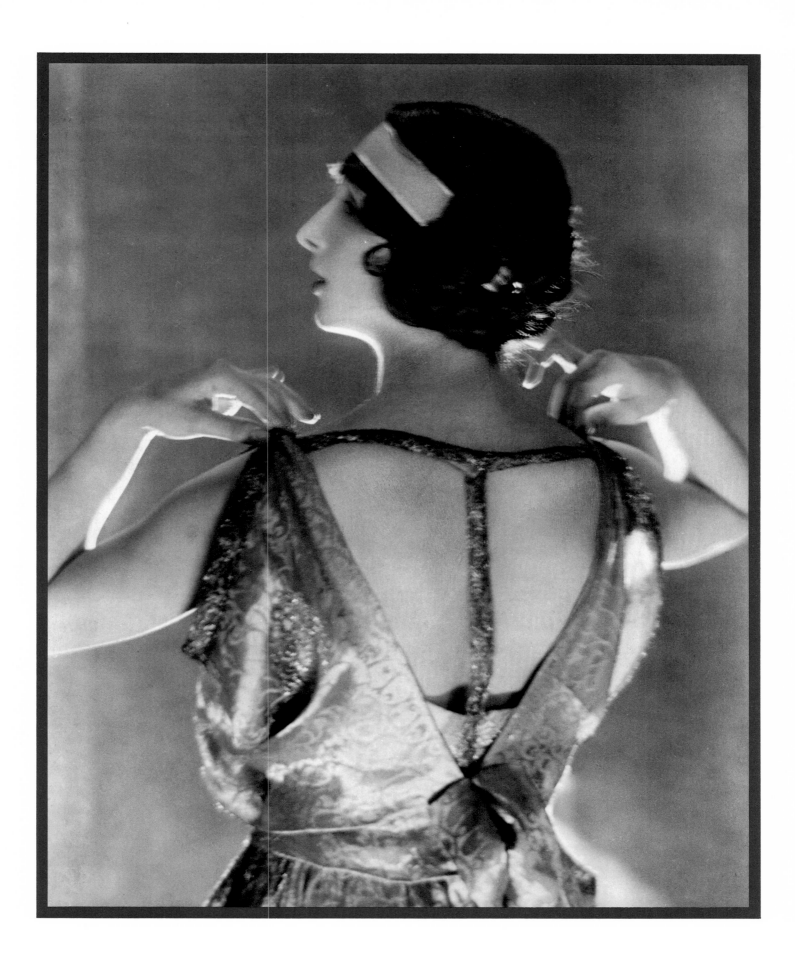

13 /Olga de Meyer

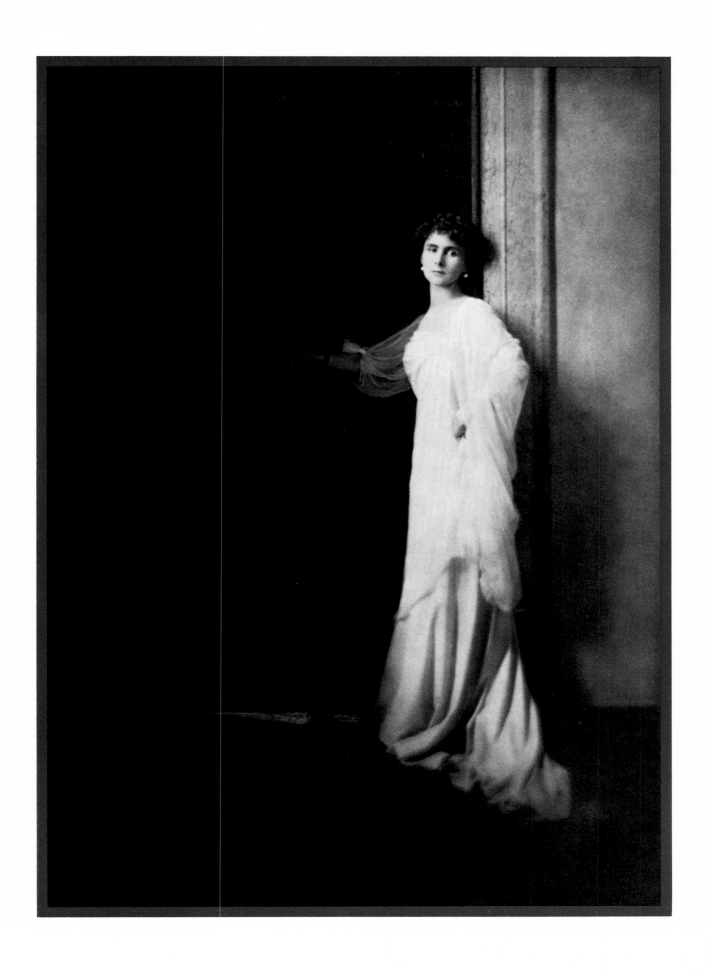

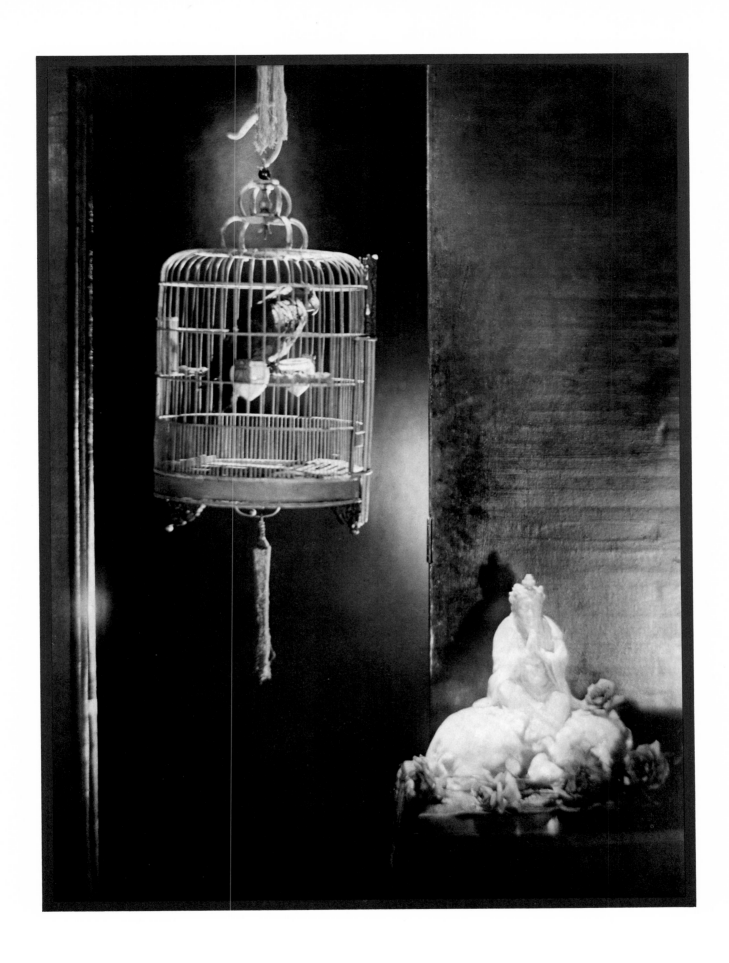

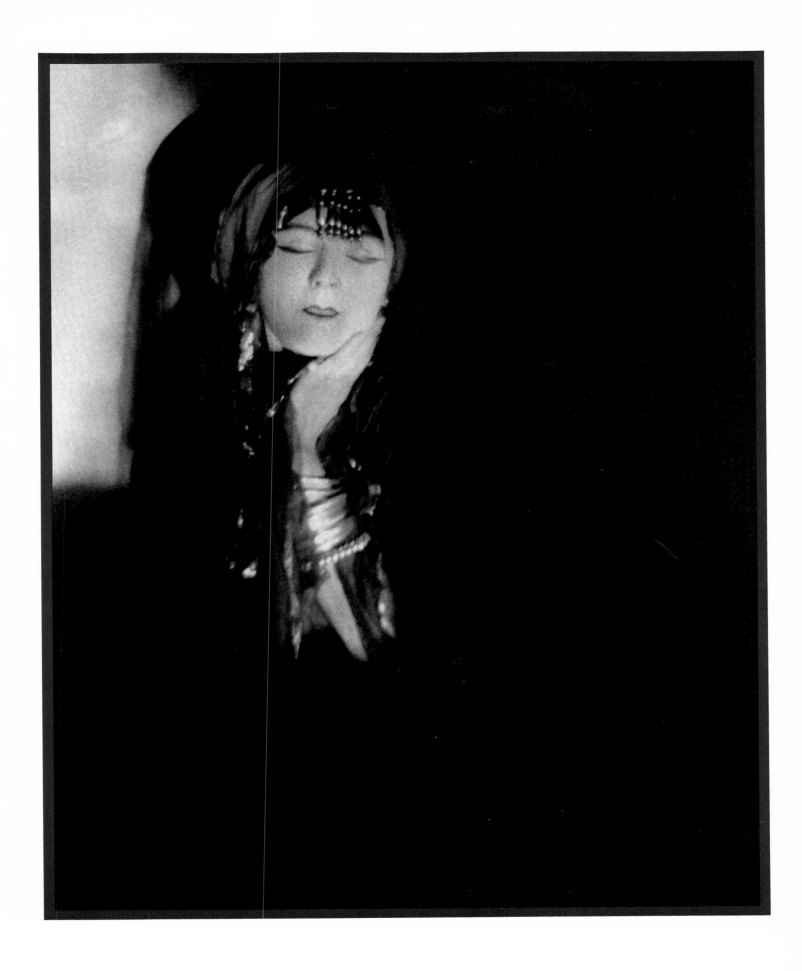

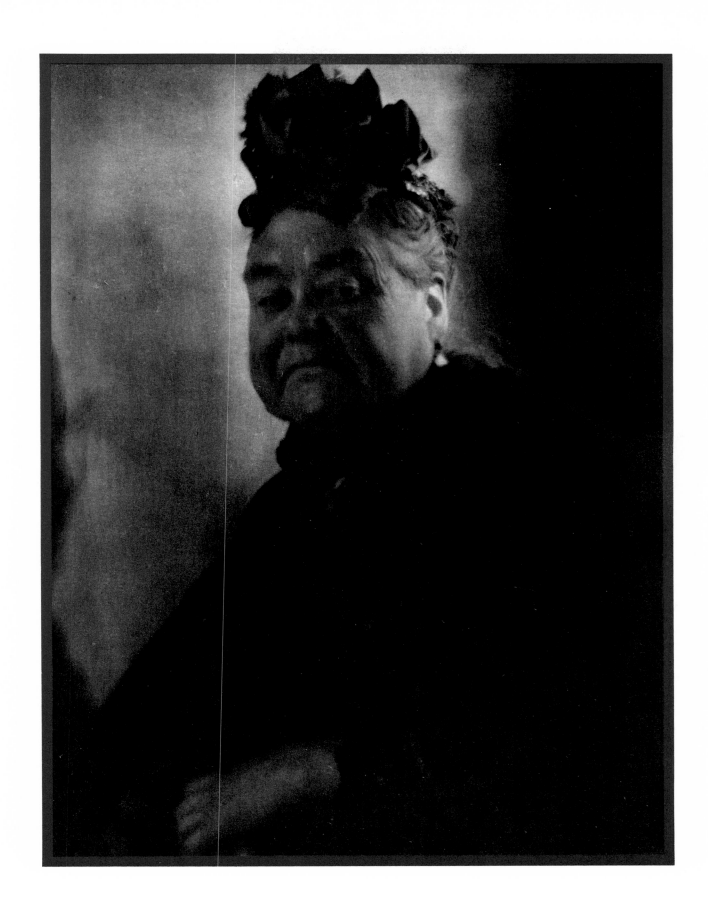

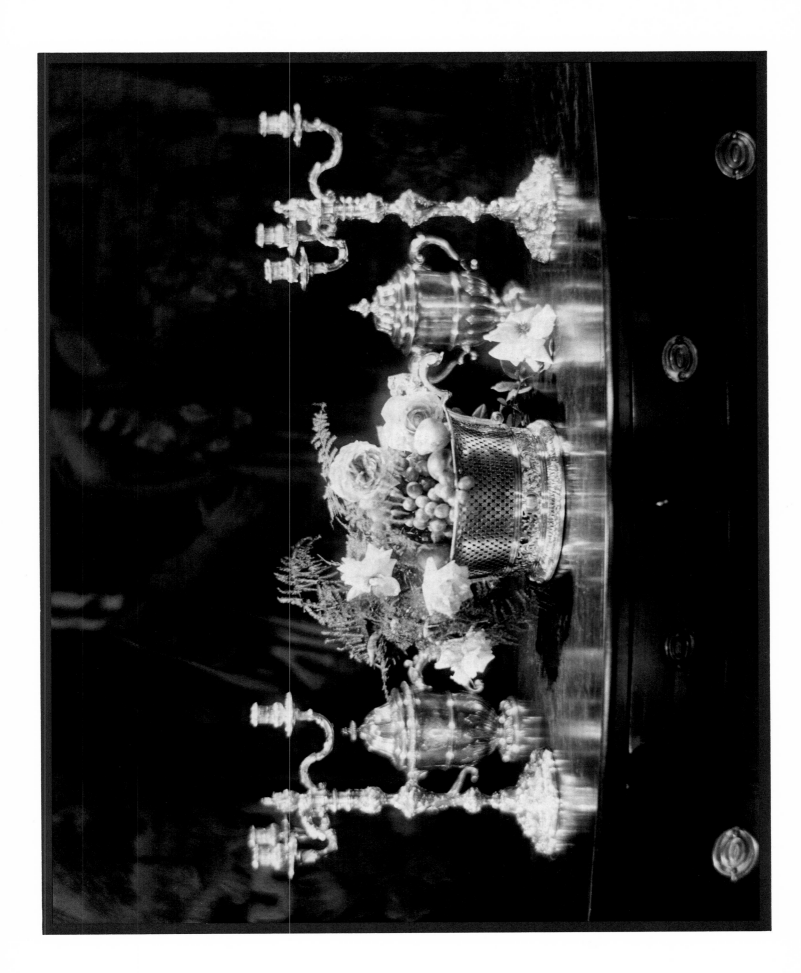

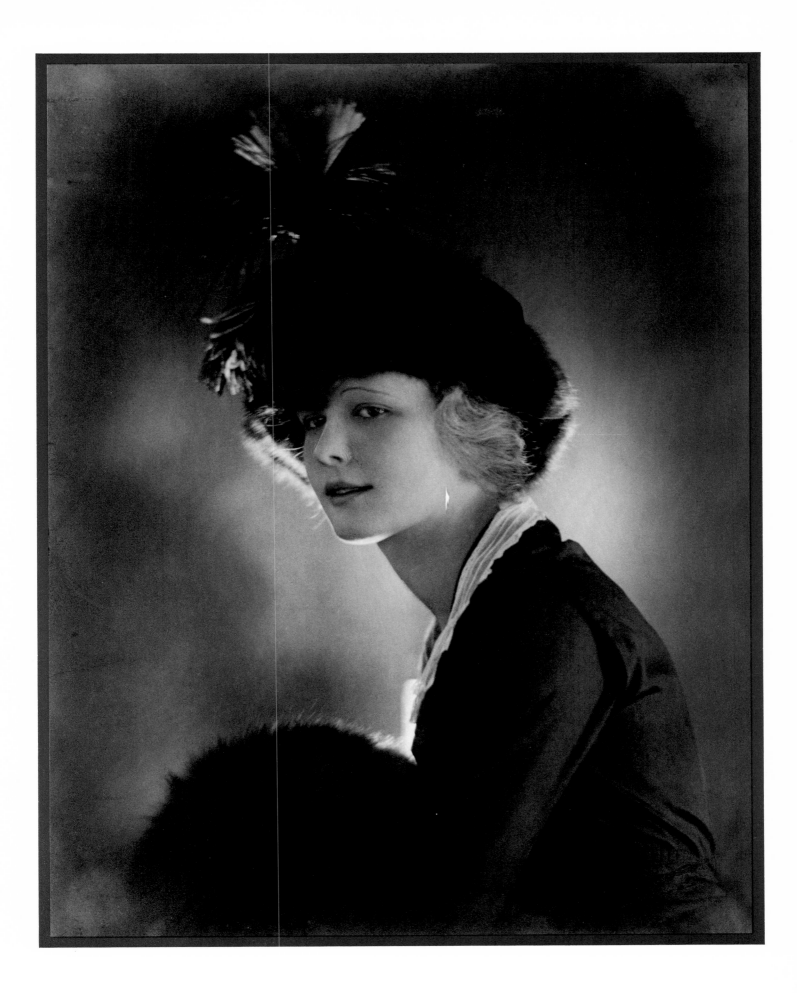

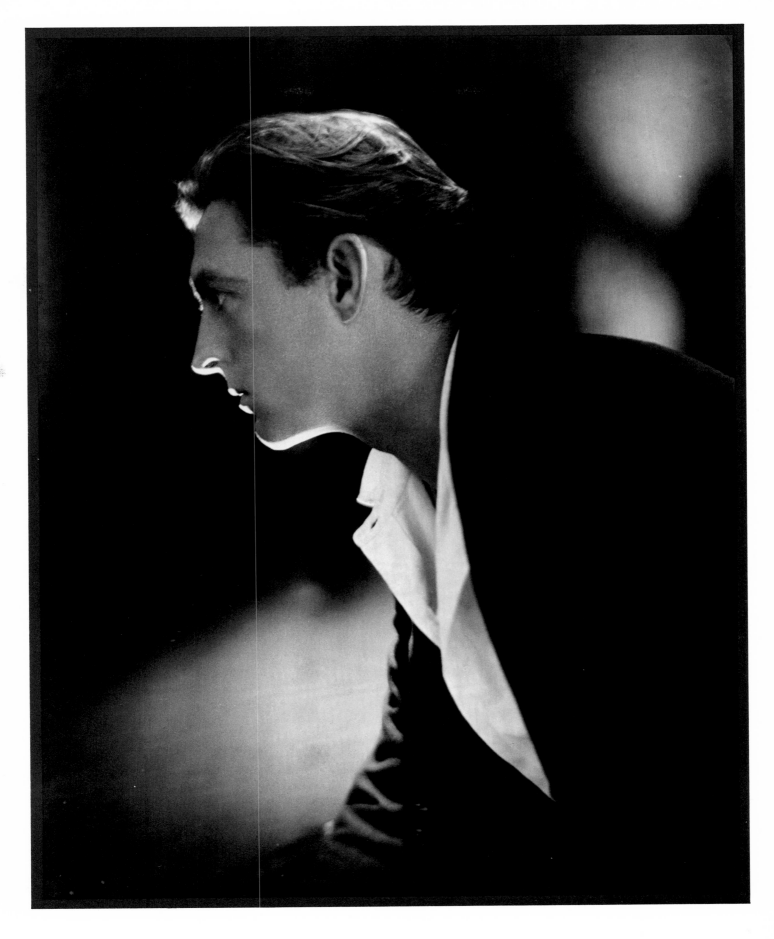

20 /Mrs. Ronald Tree

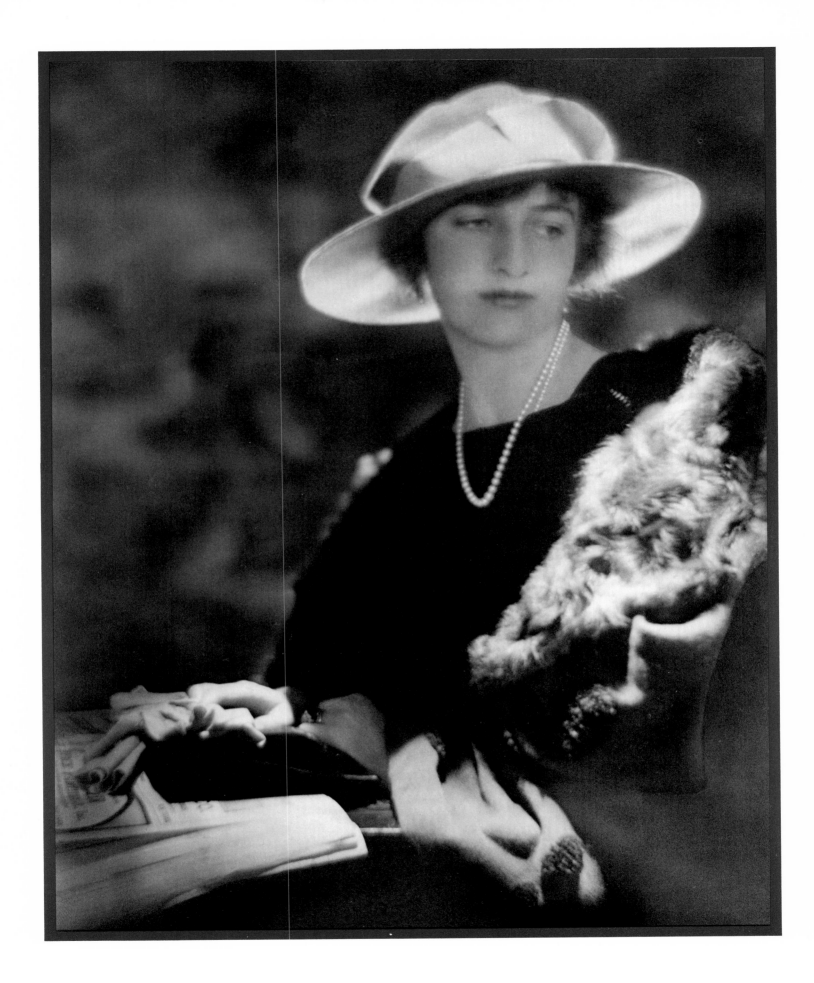

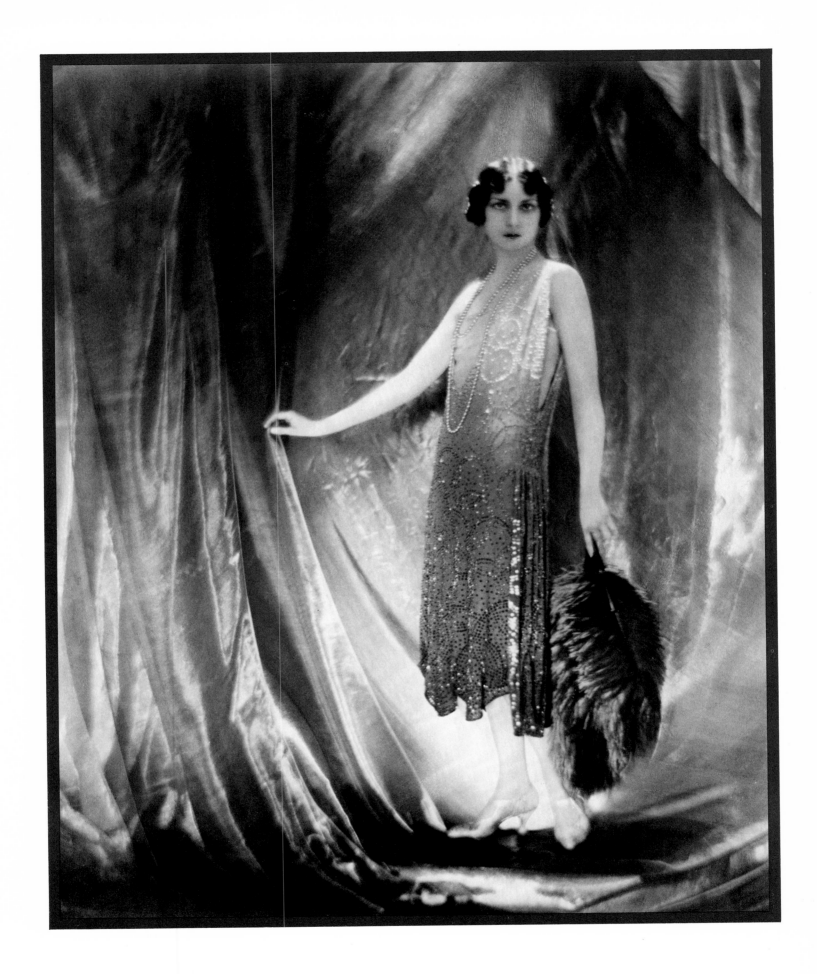

22 / Marilynn Miller

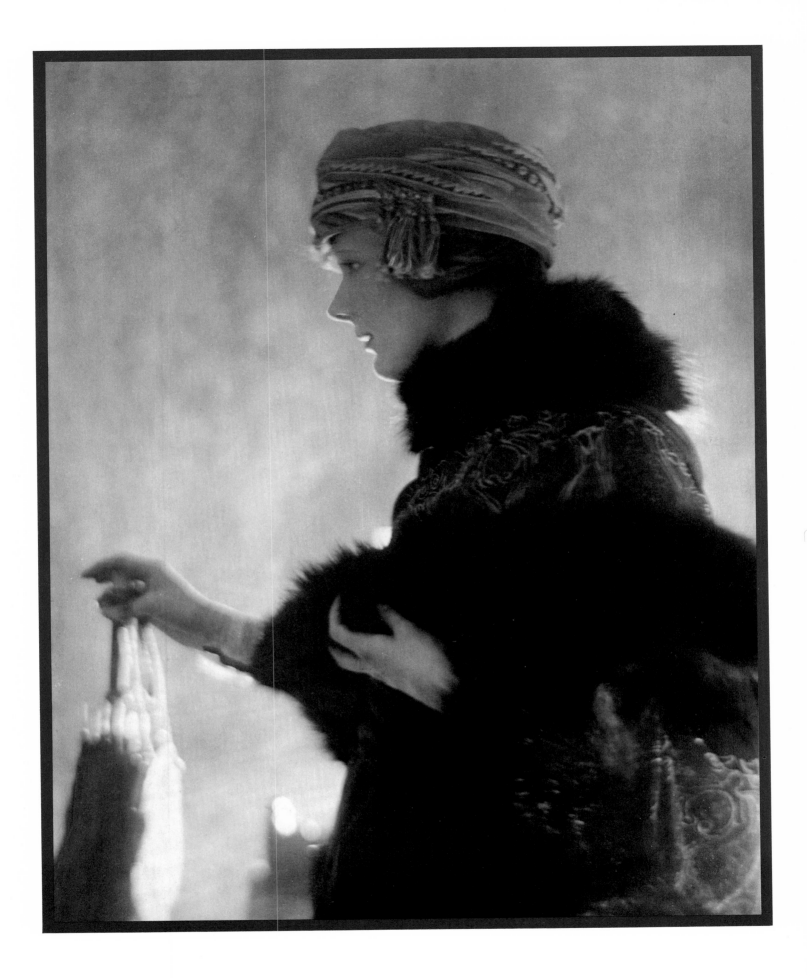

23 / George Arliss

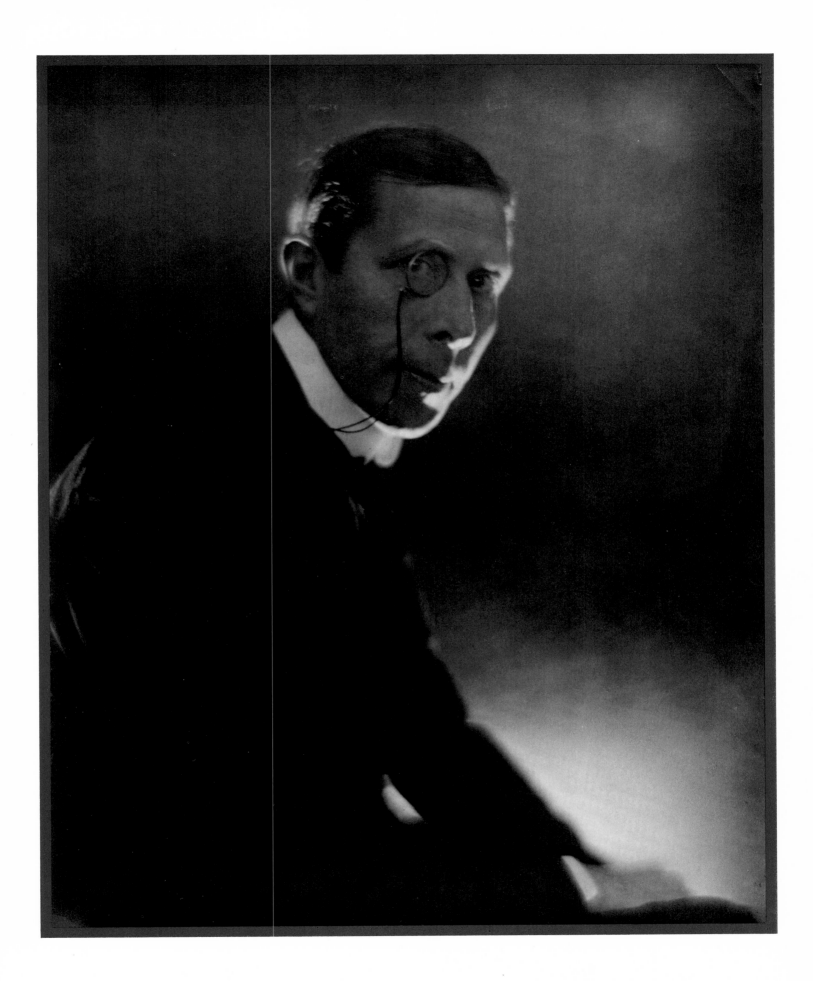

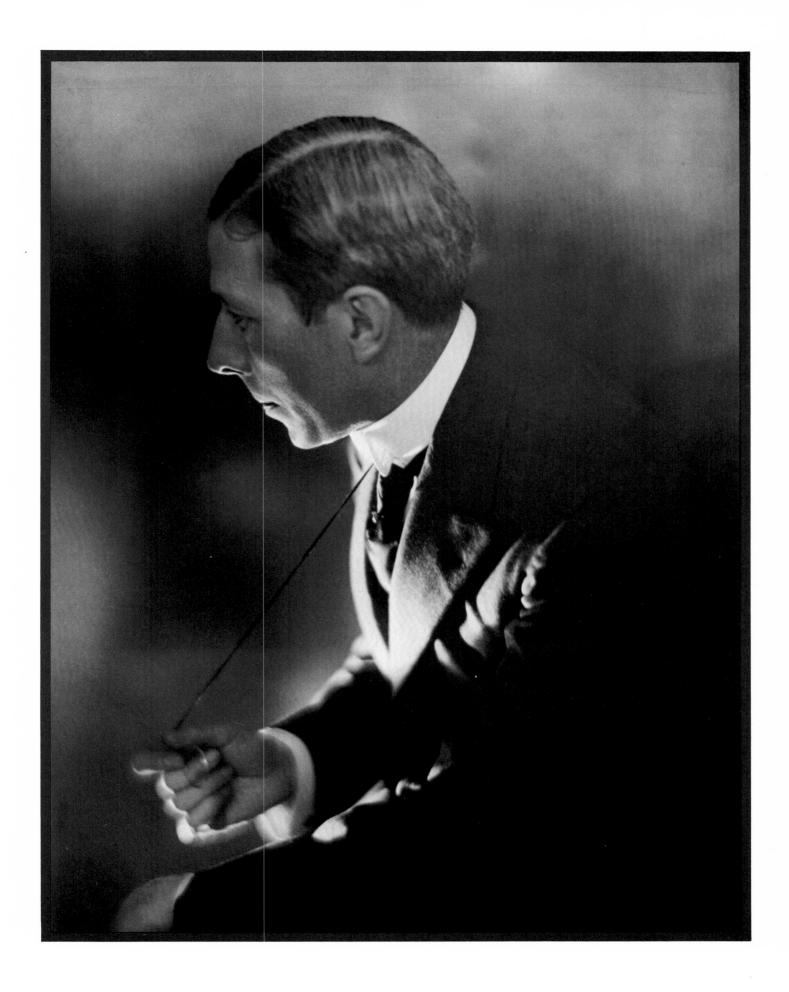

25 / Eugene O'Neill

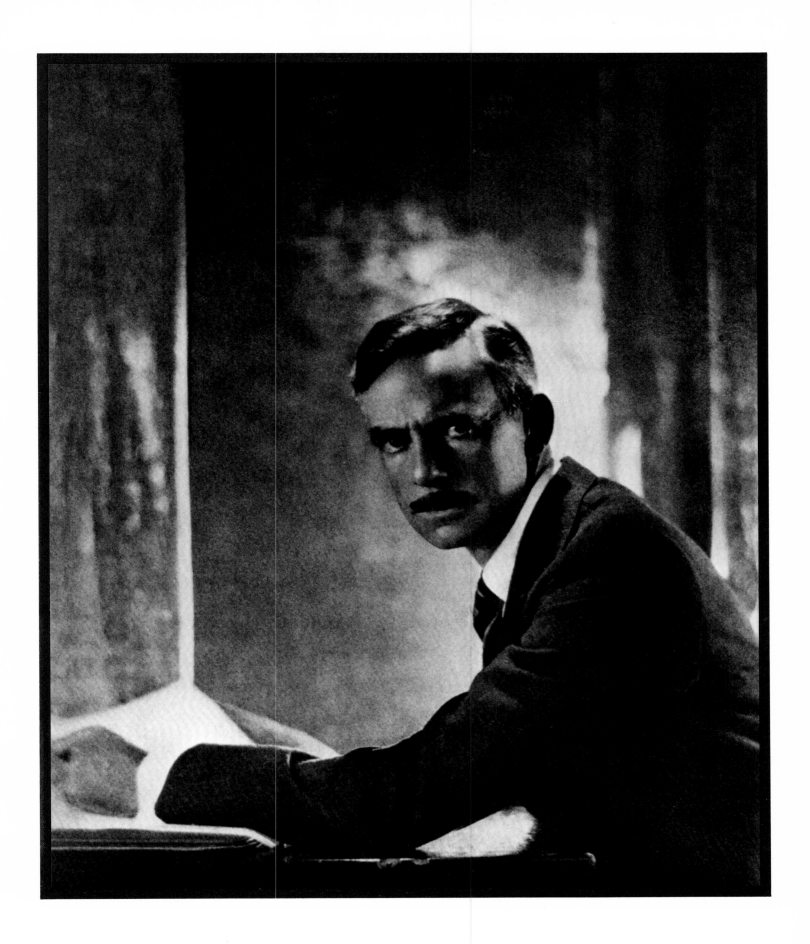

26 /Mrs. Eugene O'Neill

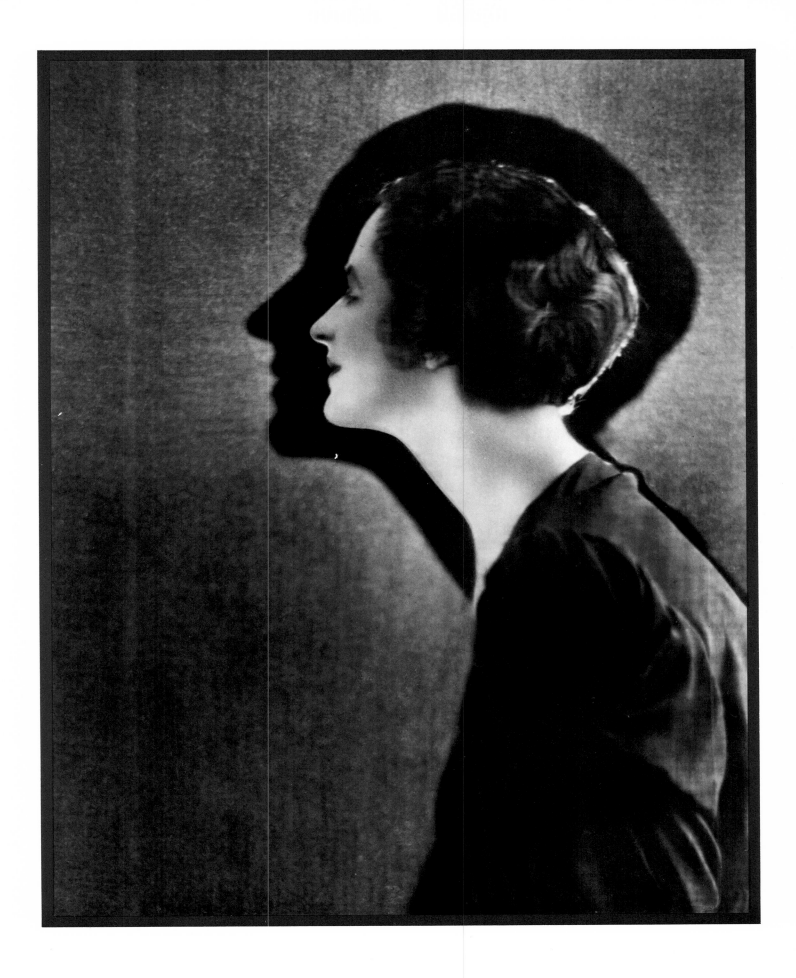

27 / Helen Lee Worthing

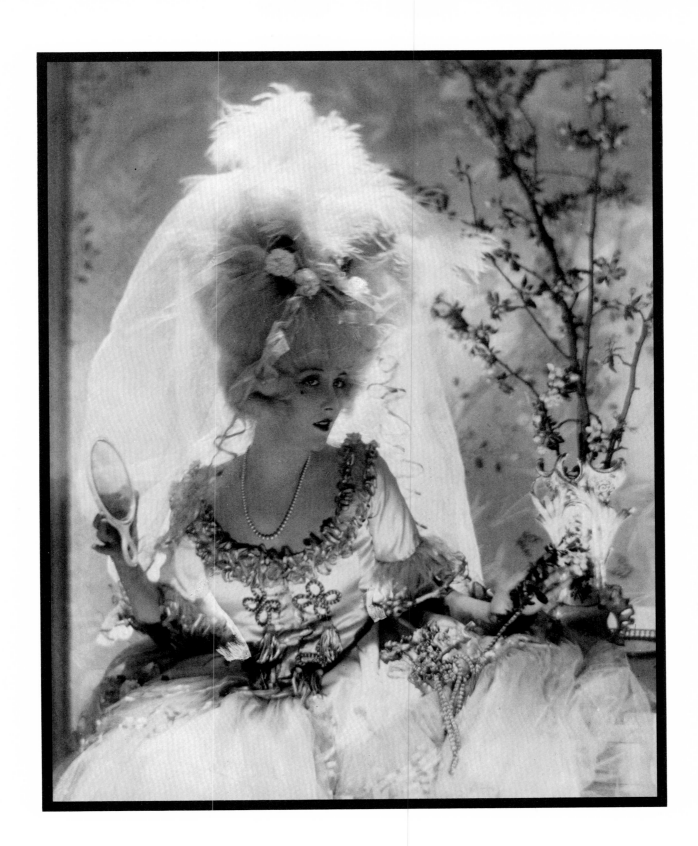

/ Child model

29 / Child model

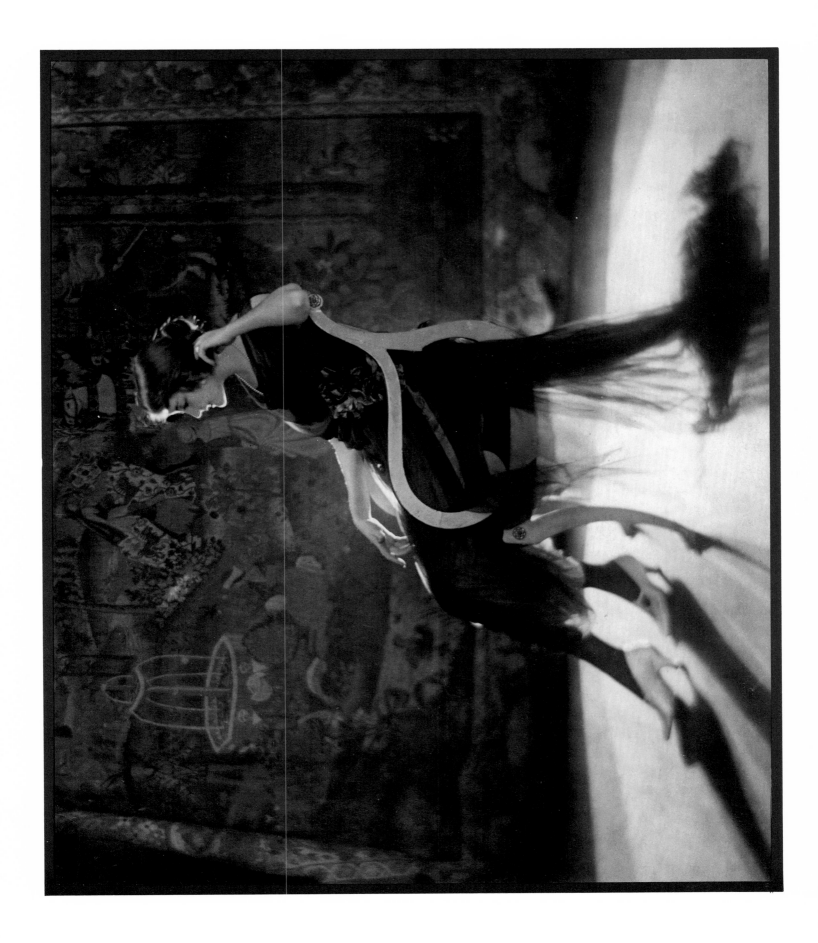

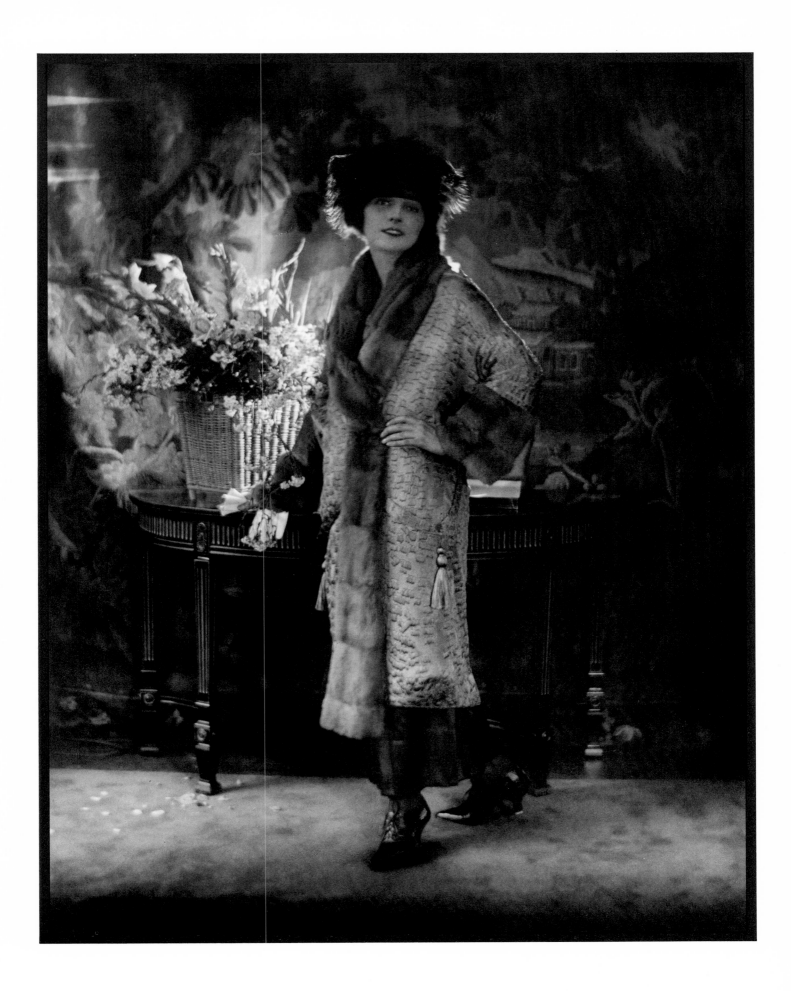

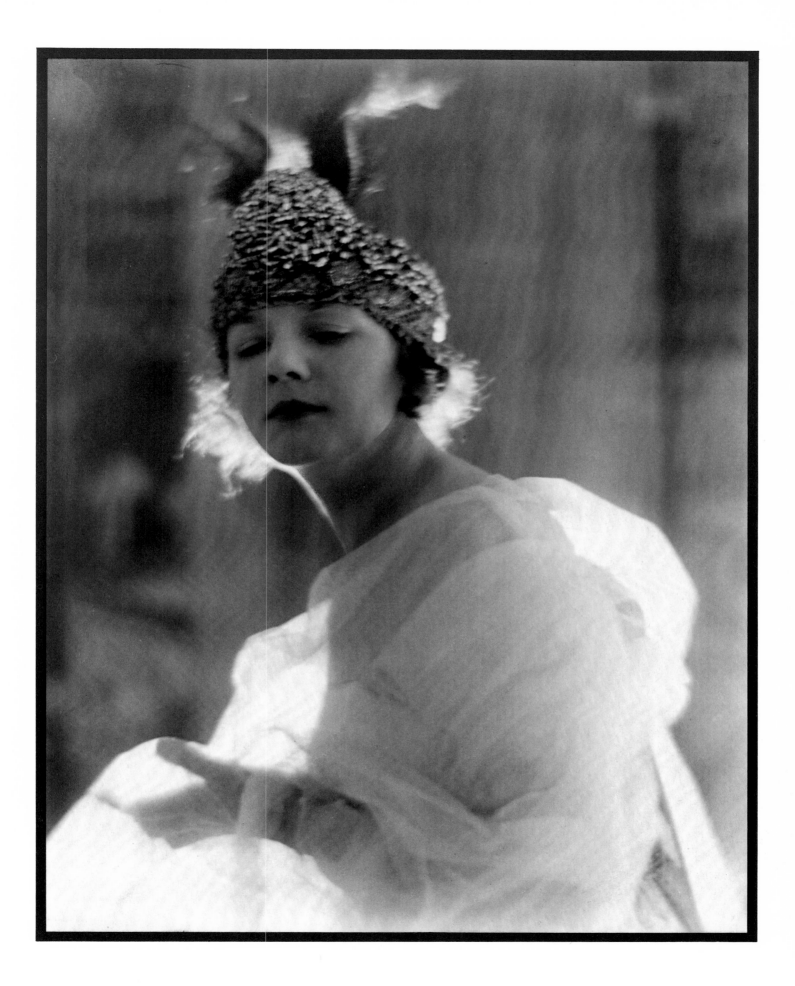

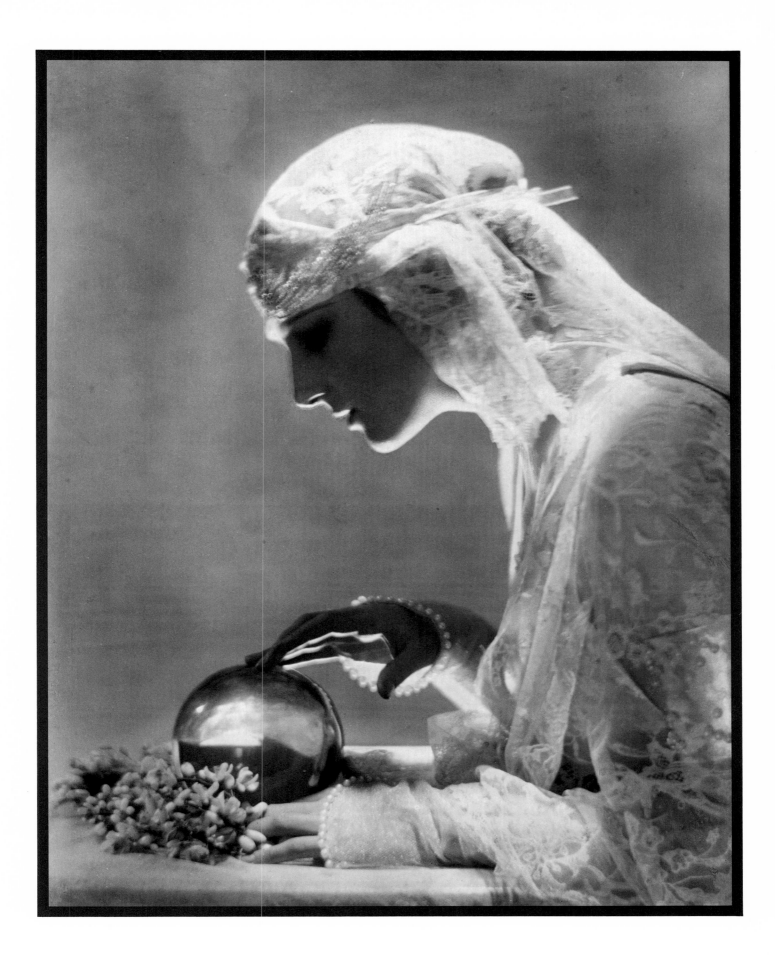

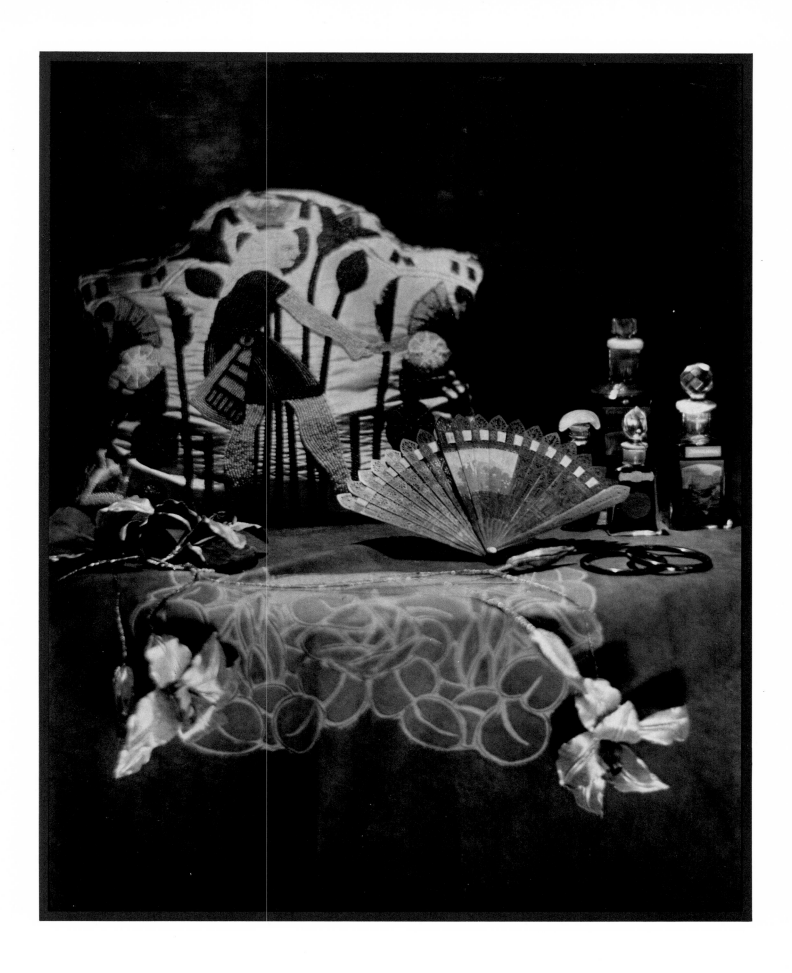

35 / Berthe modeling

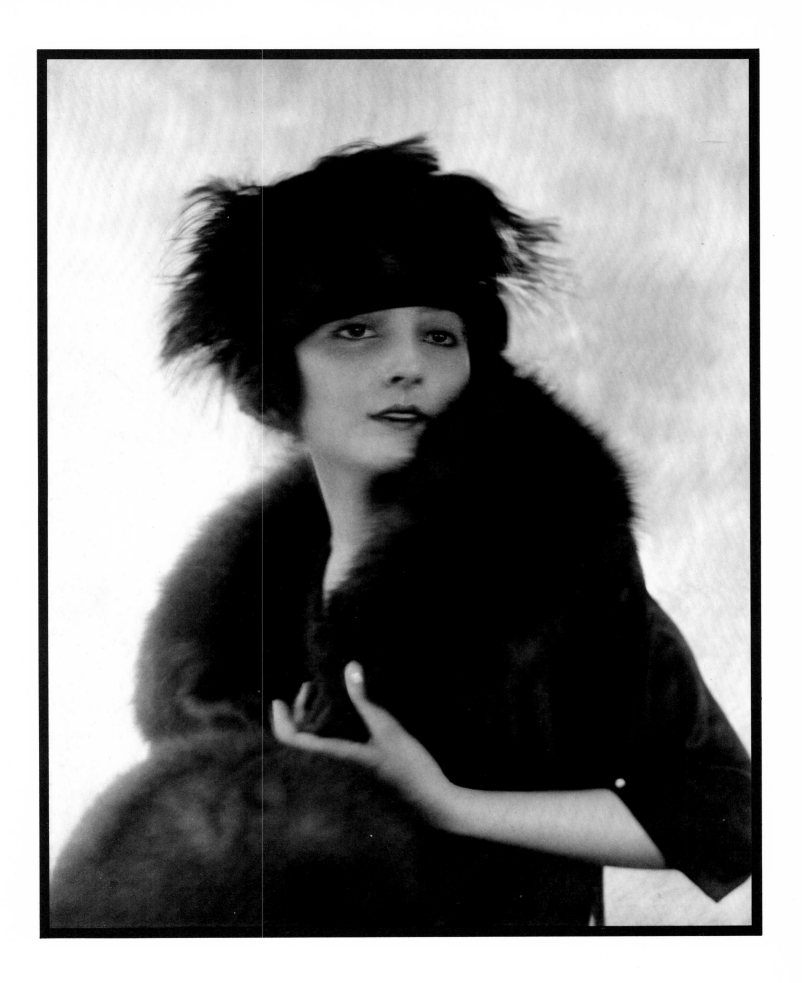

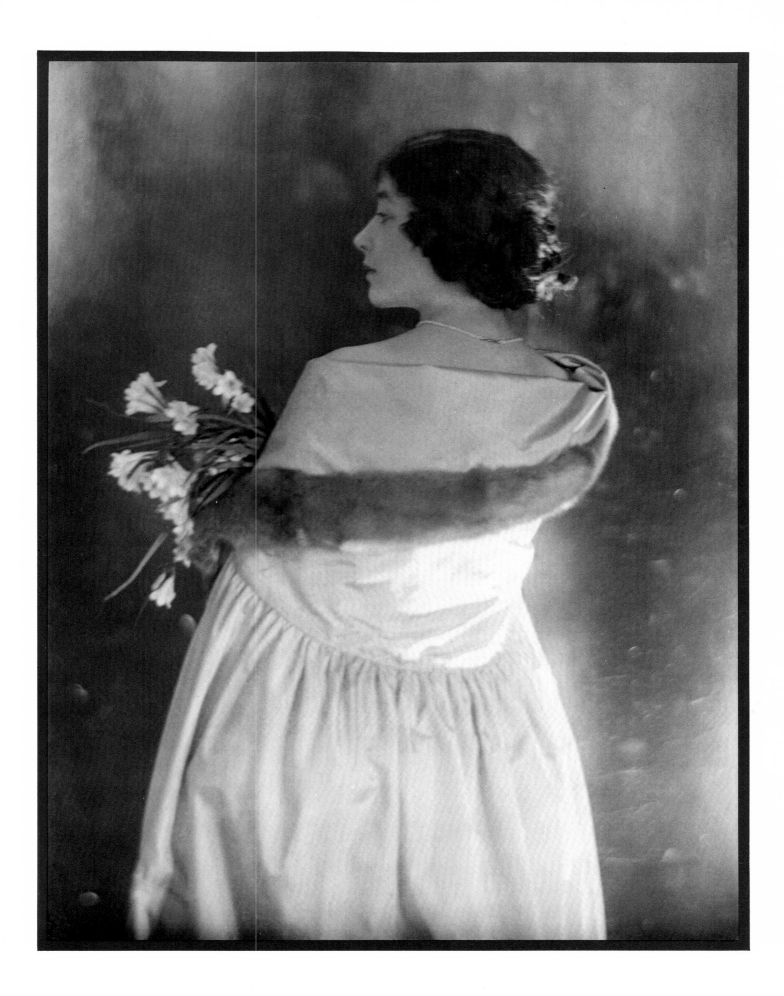

37 /Anna Pavlova

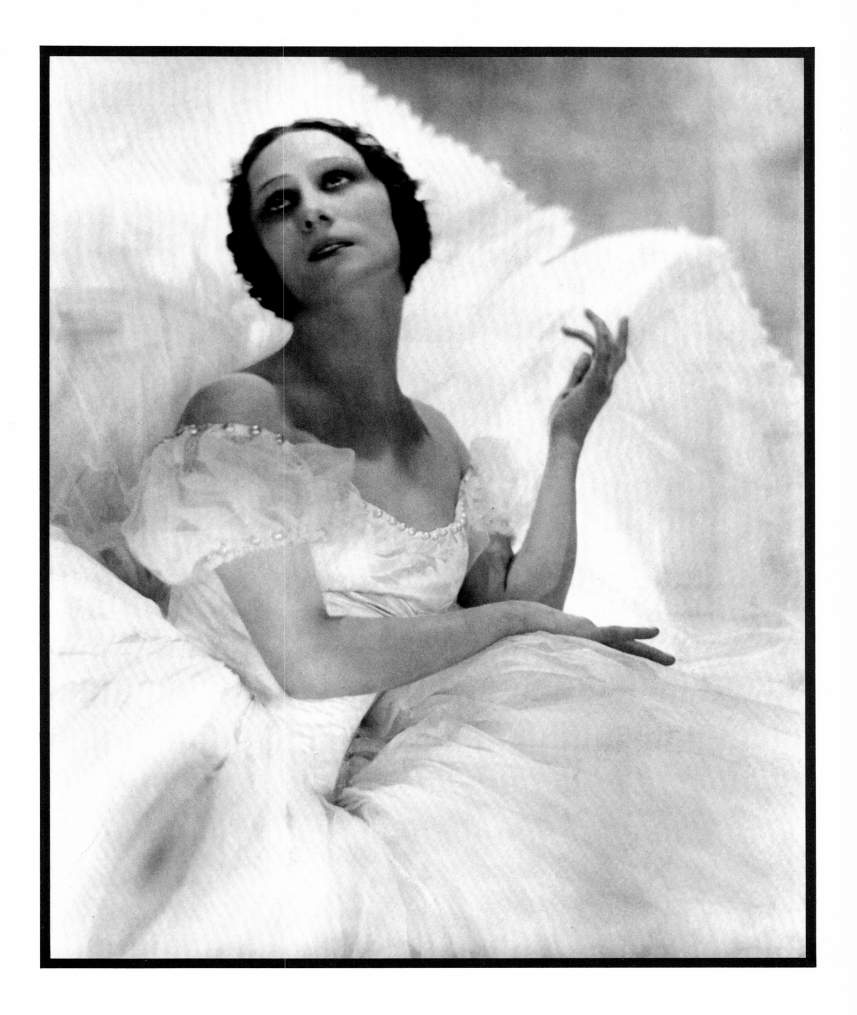

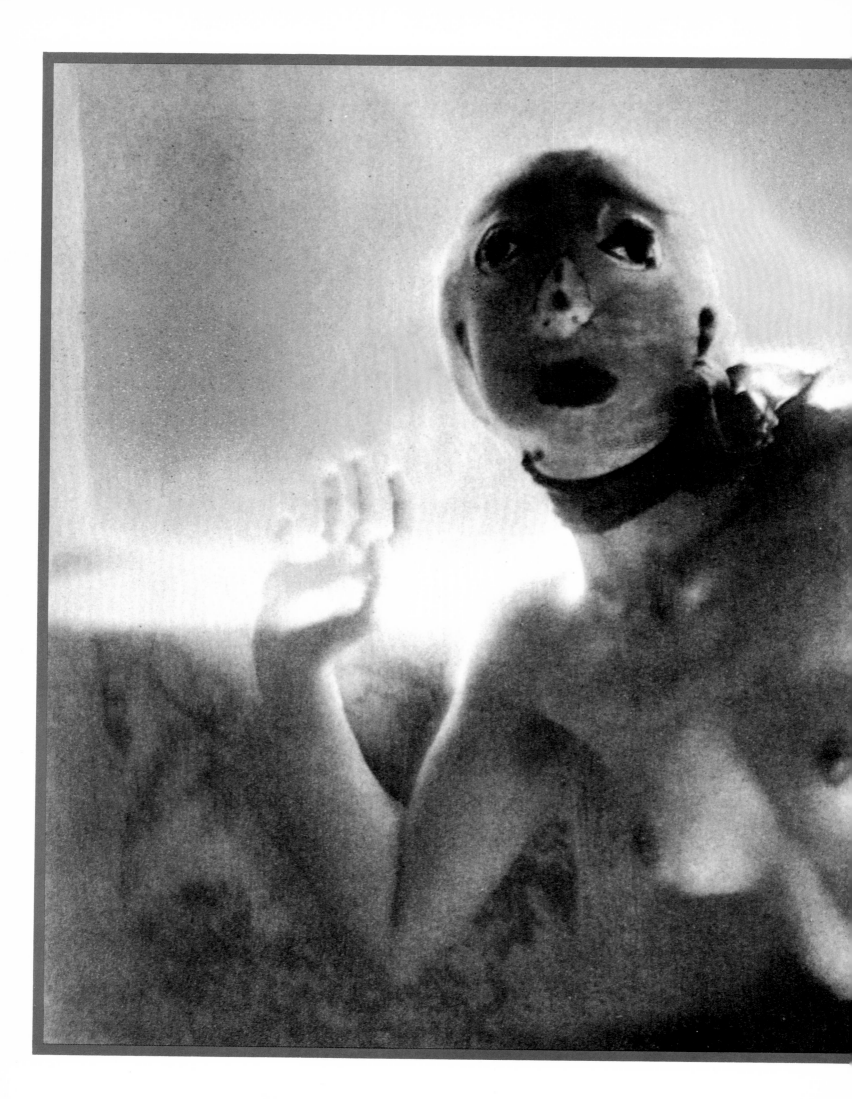

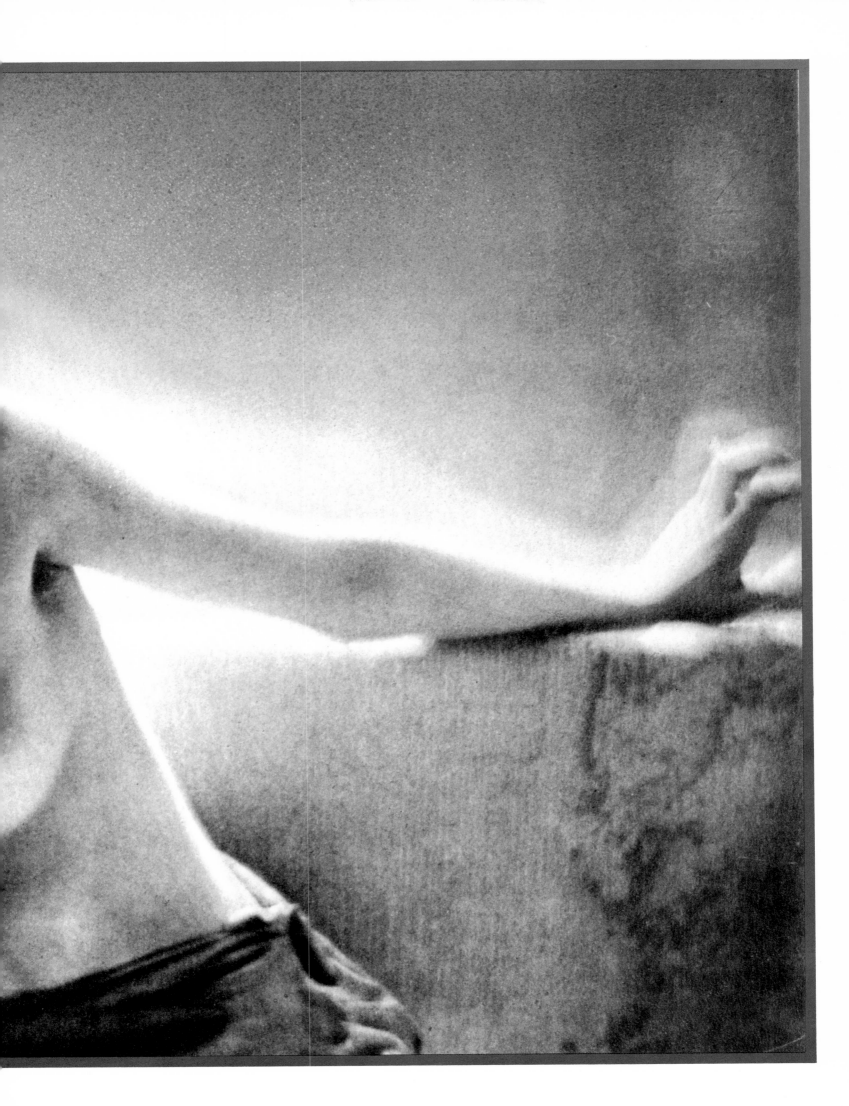

38 / Woman with a mask

The preceding pages

39 / From the *L'Après-midi d'un faune* album

The following five pages

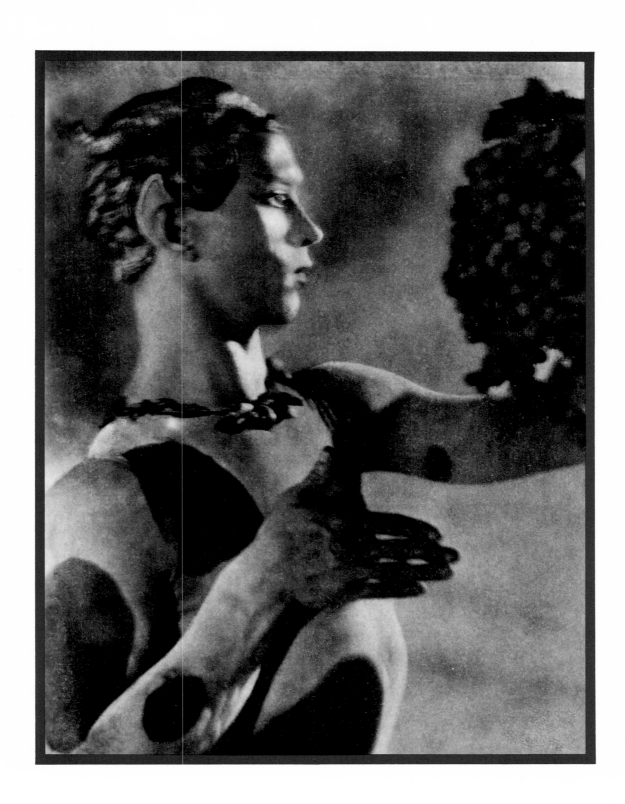

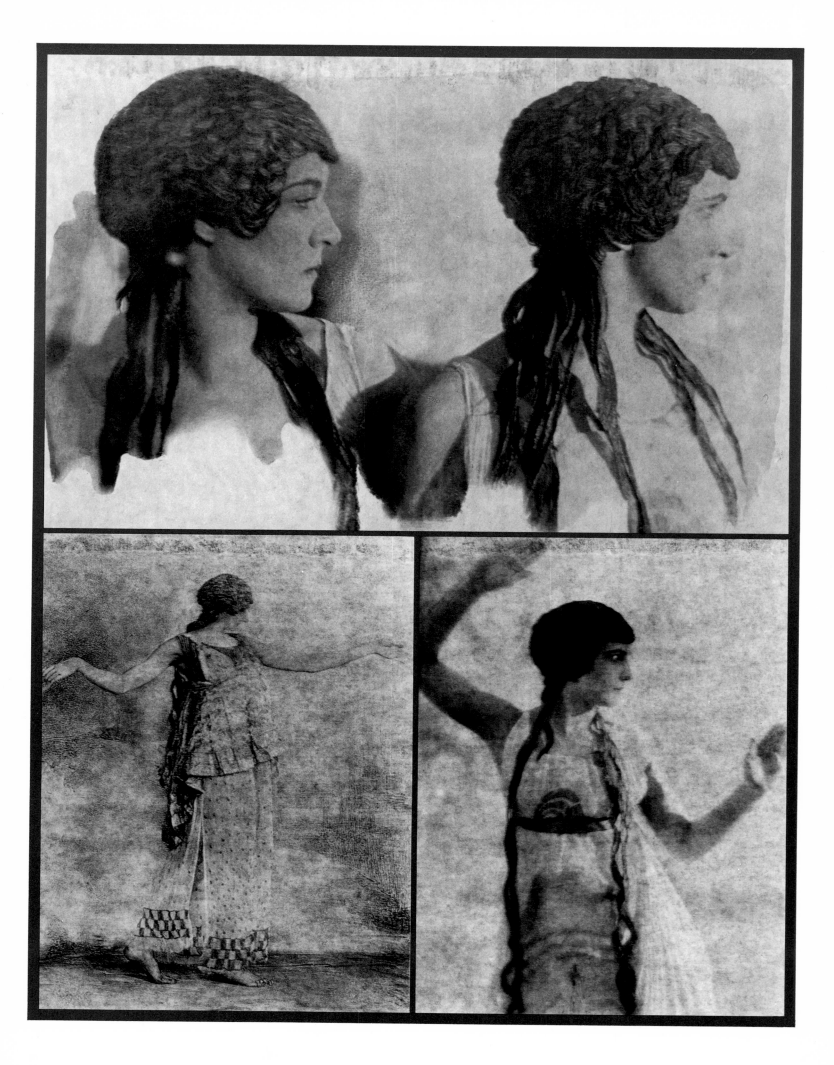

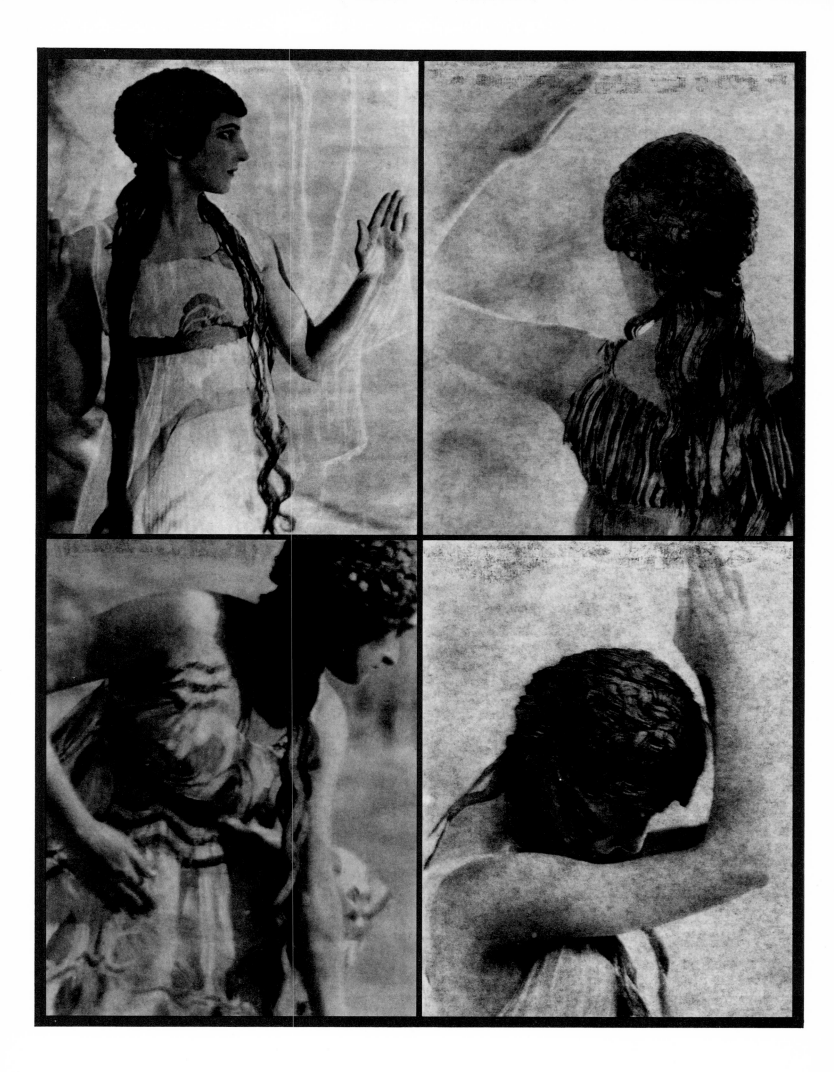

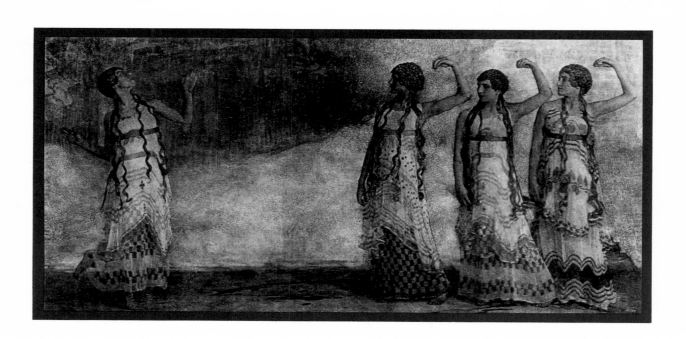

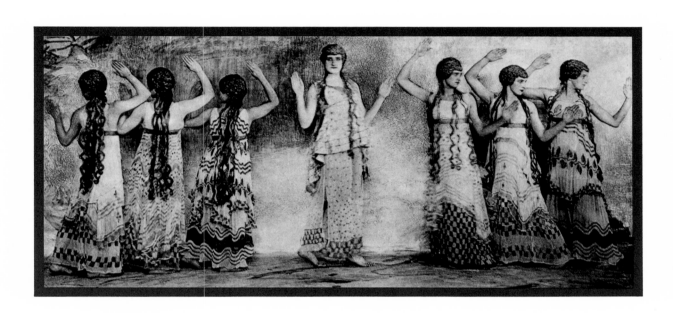

40 / Nijinsky in *Le Carnaval*

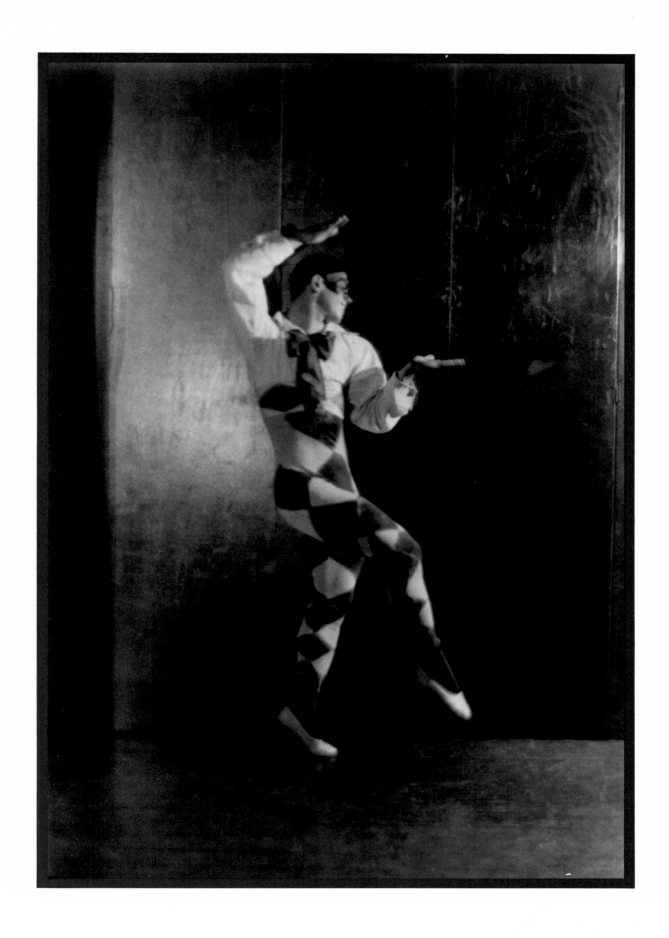

41 /Charles Chaplin

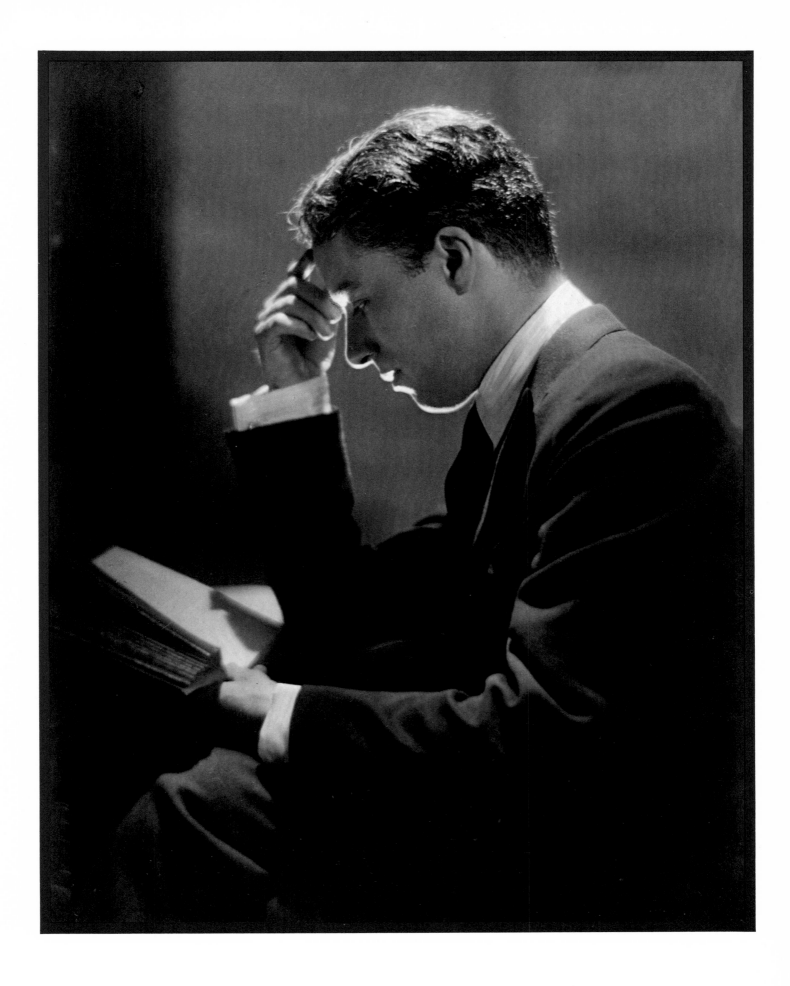

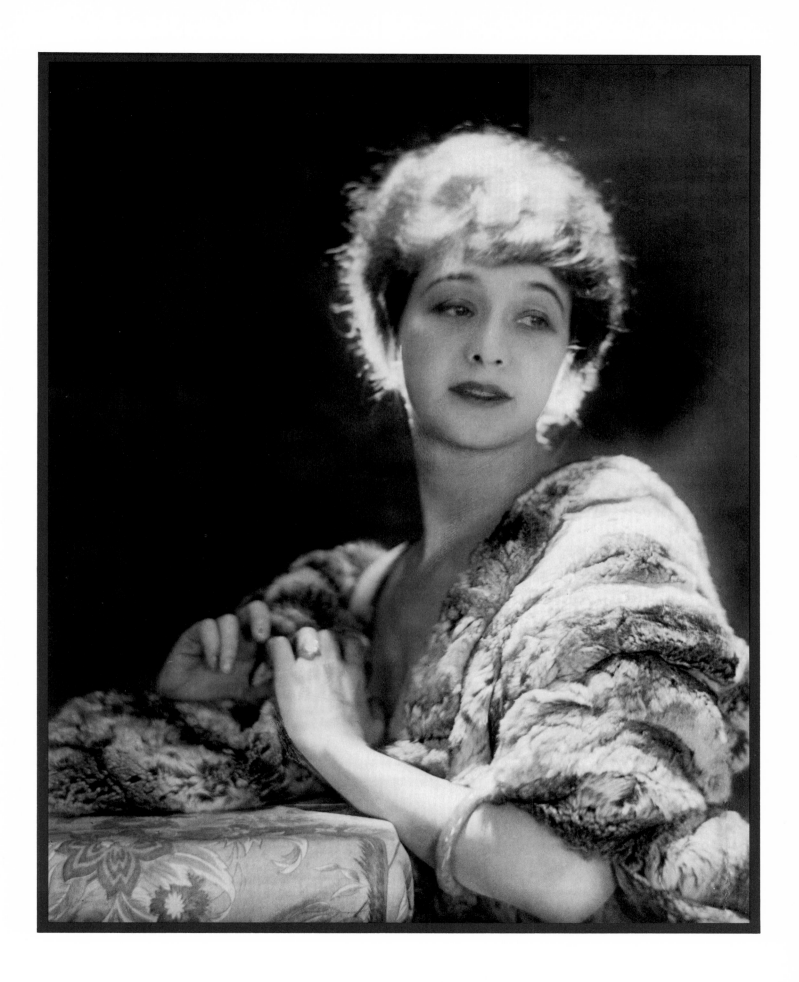

43 / **Mrs. Walter Rosen**

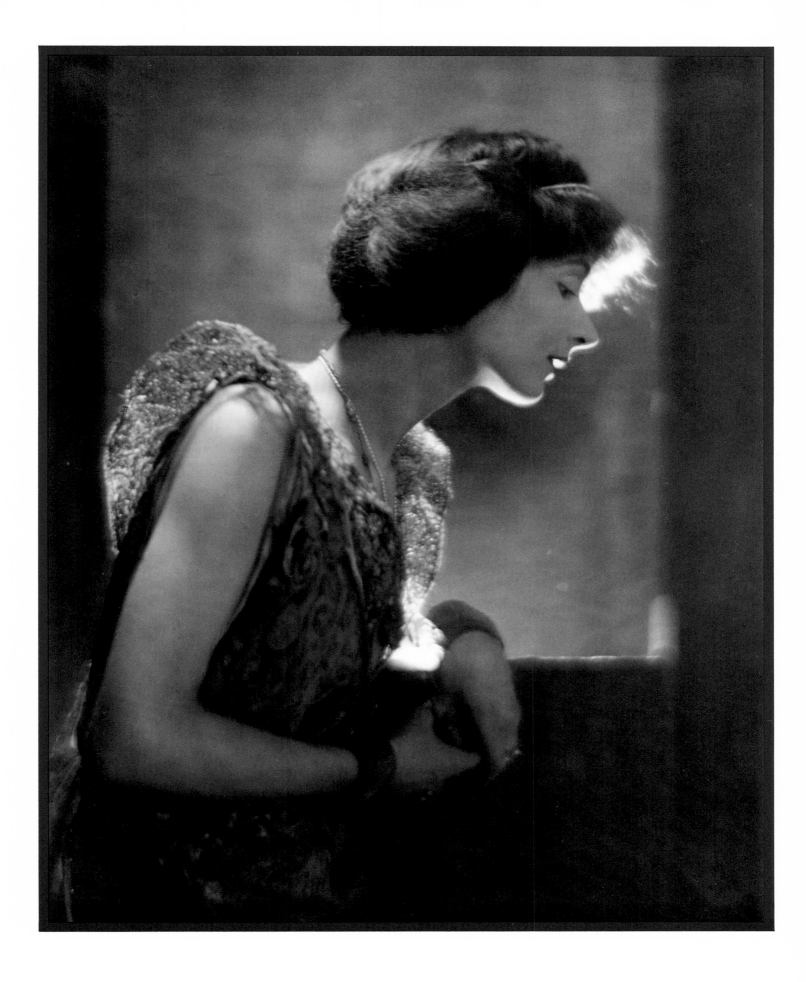

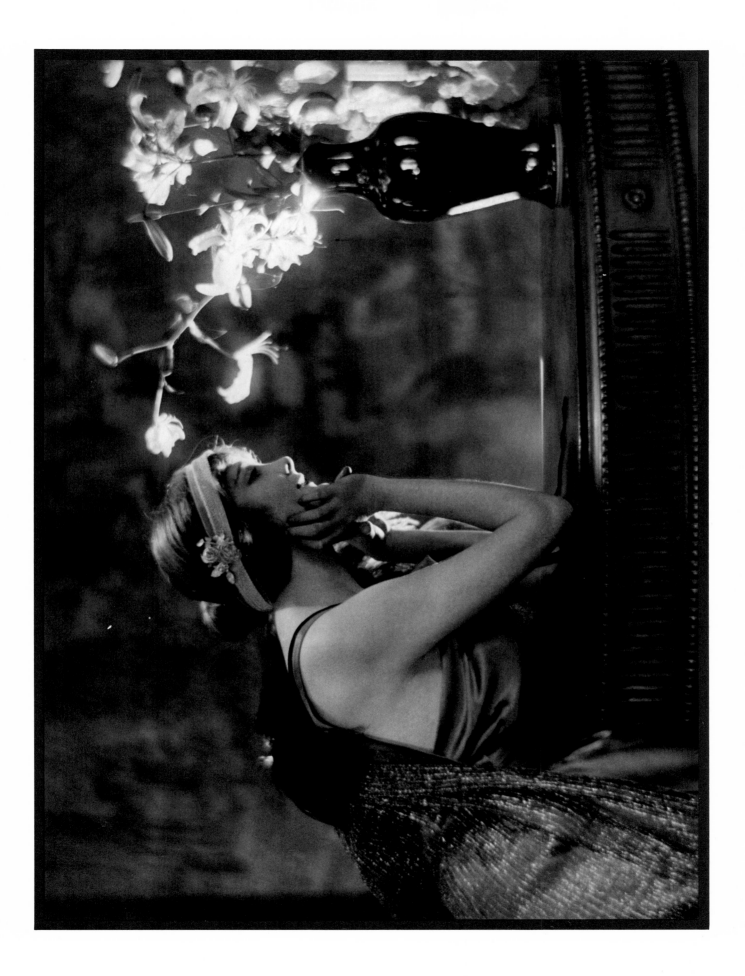

45 / Table setting for a wedding

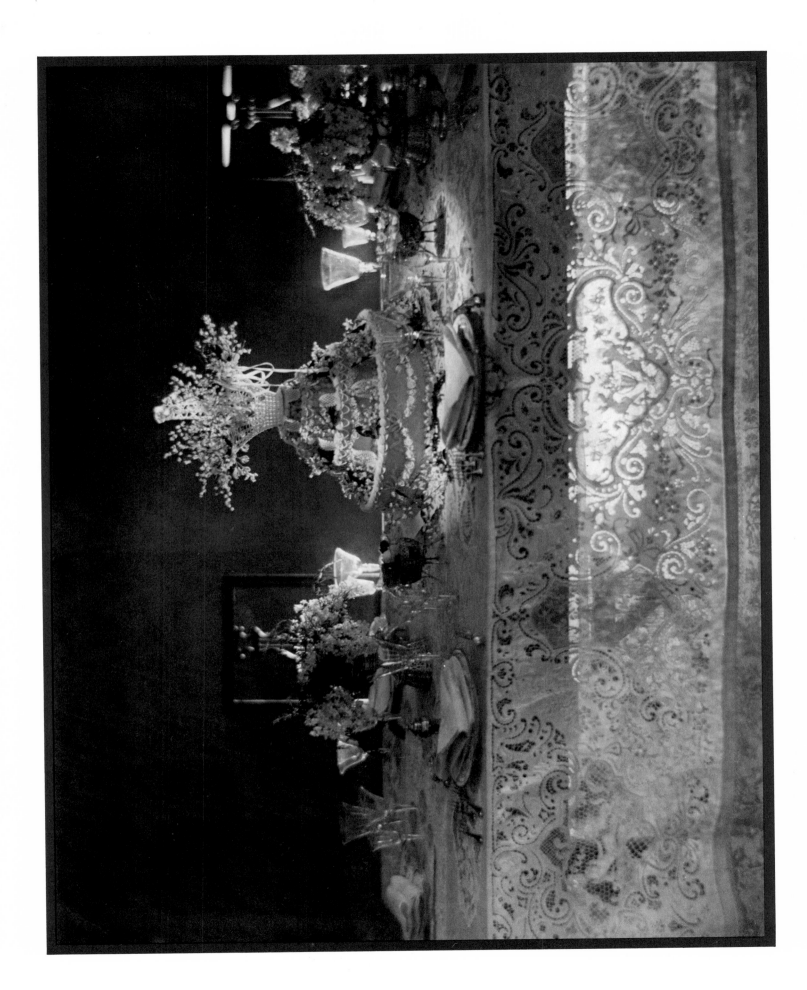

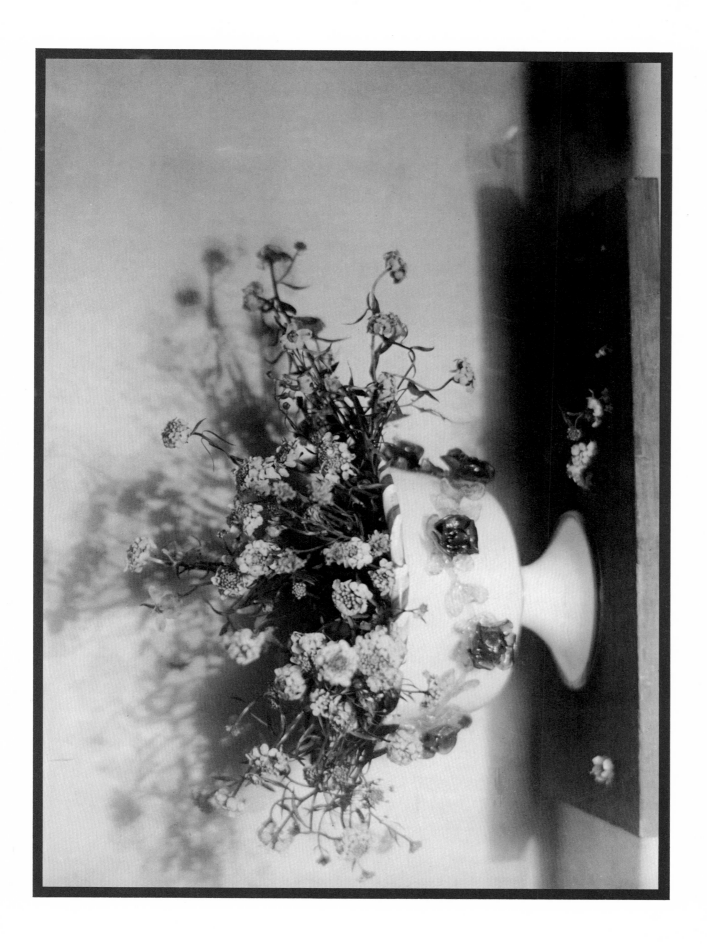

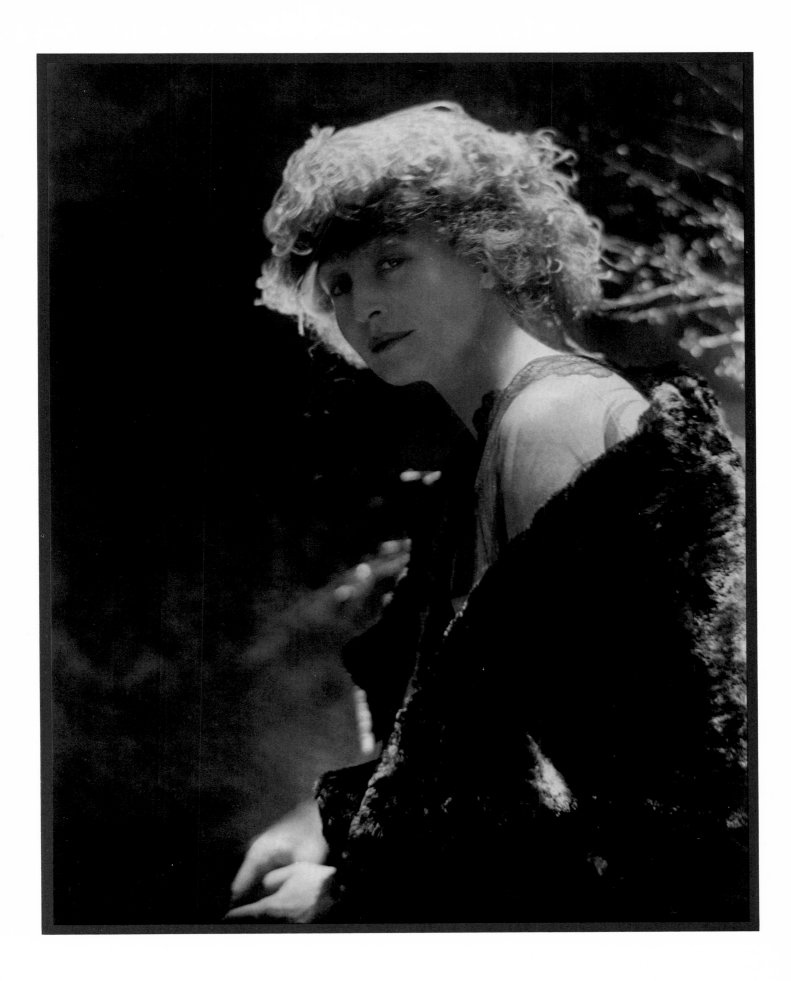

49 / Nellie Melba as Marguerite in Gounod's *Faust*

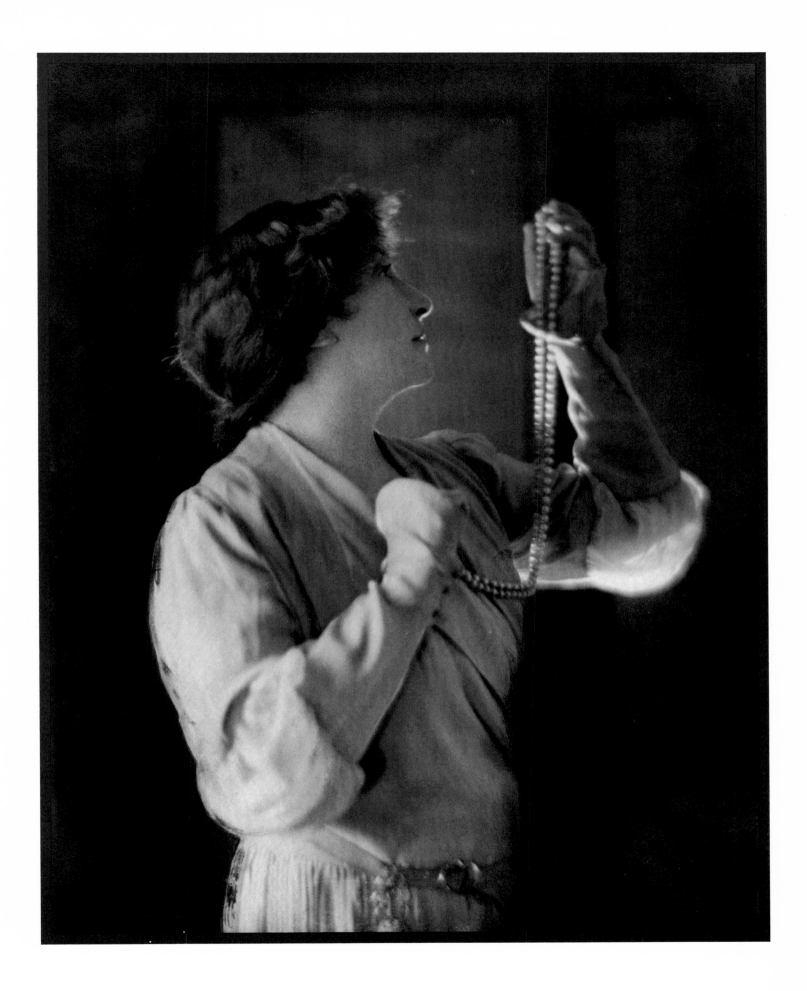

50 / Mrs. Thomas Whiffen

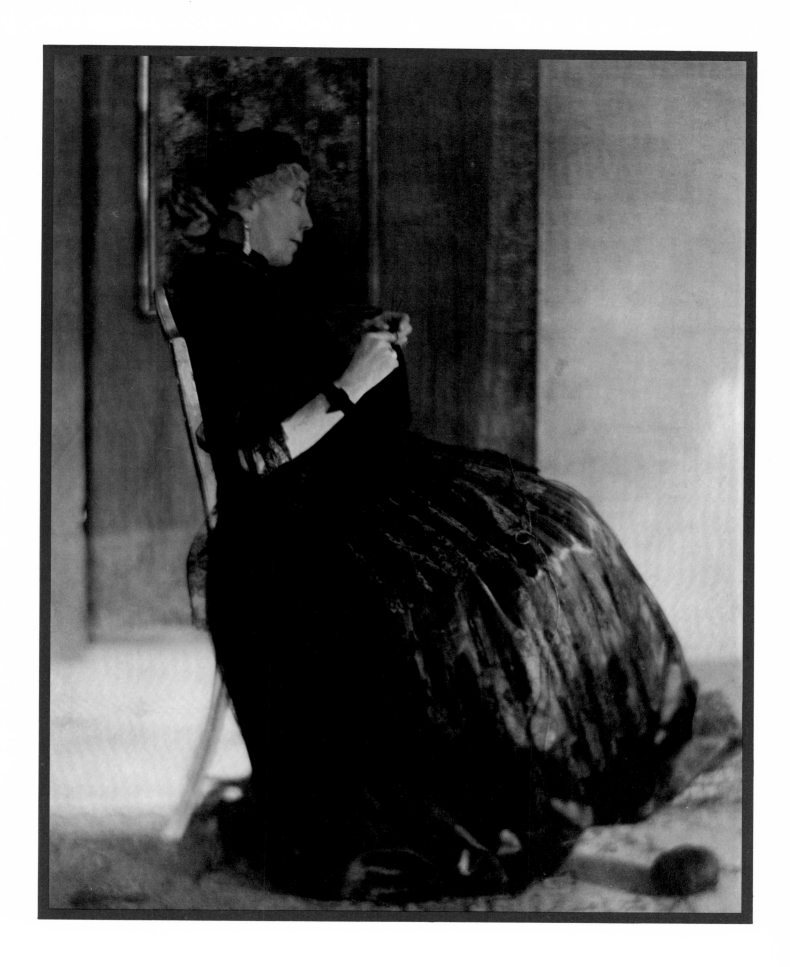

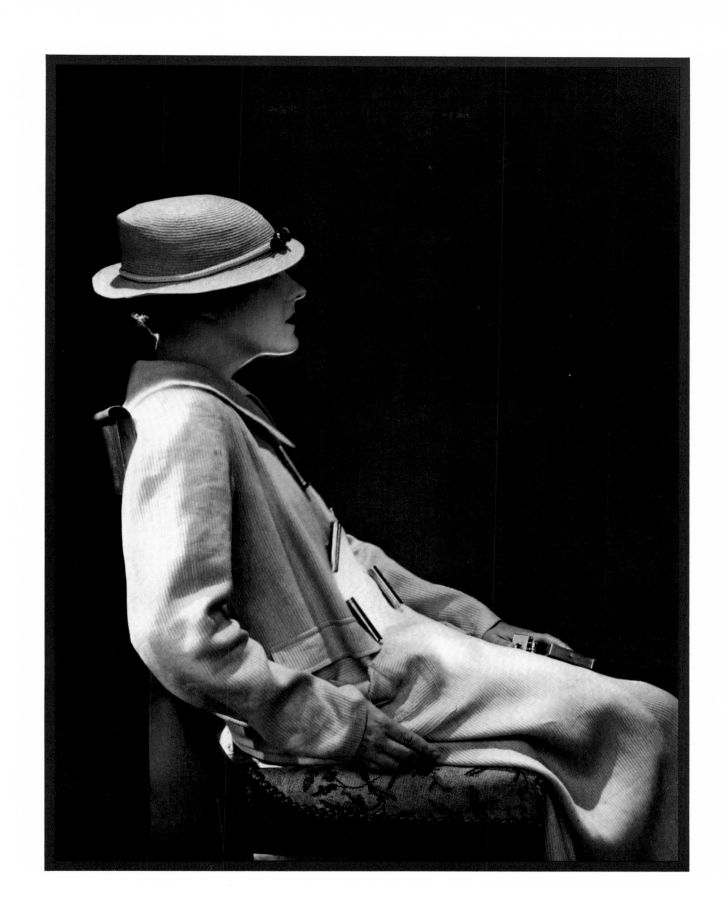

Prints have in most cases been reproduced at actual size. Retouching visible on some prints was done at the time of their original use.

Notes and Credits

From 1914 until the early twenties, successive issues of Condé Nast's *Vogue* and *Vanity Fair* were dominated by page after page of Baron de Meyer's elegant photography. An exhausting but highly rewarding search of the Condé Nast files, made possible through the courtesy of Paul Bonner, yielded a handsome trove of original de Meyer prints, the quicksilver brilliance of their lighting and the soft shadowy focus for which he was famous beautifully preserved. This initial success was followed by more discoveries of prints and de Meyer memorabilia, some quite unexpected, in museums and private collections both in the United States and in Europe. Though quantities of his voluminous output of portrait and fashion photography had vanished in the course of years, the prints and negatives alike destroyed, there were fortunately still a number of admirers who had saved and cared for examples of his most important and brilliant work. Rarer, yet important to a complete understanding of his achievement, are the early pictures, dating from the 1880's to just past the turn of the century, when as a young man he was establishing a reputation for himself among contemporary photographers. In 1907 and again in 1912, Alfred Stieglitz publicized these early de Meyer photographs with shows at his 291 Gallery in New York. They were enthusiastically received and reviewed, and subsequently numerous prints and gravures appeared in *Camera Work* and *The Craftsman*. Several of these are reproduced here. Examples from his other great pre-*Vogue* masterwork, the album of photographic studies of Nijinsky and other members of the Diaghilev company made in Paris in 1912, were made available for use here by courtesy of the Bibliothèque Nationale in Paris.

My special thanks and appreciation to the following people, whose interest and contributions have been of great value in making this book possible: Louise Dahl Wolfe, Sir Cecil Beaton, Lillian Farley, Mme Igor Stravinsky, Gail Buckland, Vera Gawansky, Parmenia Ekstrom, Michael Sweeley, Diana Vreeland, Robert Baral, Prince Vladimir Romanoff, Albert Newgarden, Dorothy Howard Schubart, Mme André Gremela, Flora Irving, Anita Leslie, Robert Maplethorpe, Valerie Lloyd, Georgia O'Keeffe, the late Mrs. Tudor Wilkinson, Reynaldo Luza, Lincoln Kirstein, Lewis P. Lewis, Polaire Weissman, Mrs. Julian Vinogradoff, Lucien Goldschmidt, Horst.

I am greatly indebted to the following individuals and institutions for their generous cooperation in research and for their assistance in making available for reproduction original prints and photographs:

Paul Bonner, Director, Book Division, Condé Nast Publications, New York, New York

Weston Naef, Assistant Curator, Prints and Photographic Department, Metropolitan Museum of Art, New York, New York

Donald Gallup, Elizabeth Wakeman Dwight Curator, Yale Collection of American Literature, The Beinecke Rare Books and Manuscript Library, Yale University, New Haven, Connecticut

Christine Hawrylak, Assistant Curator, The International Museum of Photography at George Eastman House, Rochester, New York

Peter C. Bunnell, Director, The Art Museum, Princeton University, Princeton, New Jersey

Diana Edkins, Research Supervisor, Photography Collection, Museum of Modern Art, New York, New York

Paul Meyers, Curator of the Theatre Collection, the Library and Museum of the Performing Arts, The New York Public Library at Lincoln Center, New York, New York

Genevieve Oswald, Curator of the Dance Collection, the Library and Museum of the Performing Arts, The New York Public Library at Lincoln Center, New York, New York

Bibliothèque Nationale, Paris, France

Stephen E. Ostrow, Director, and Diana L. Johnson, Associate Curator of Prints and Drawings, Museum of Art, Rhode Island School of Design, Providence, Rhode Island

Ealan Wingate, Director, Sonnabend Gallery, New York, New York

Scott C. Elliott, Helios Incorporated, New York, New York

Lee Witkin, Witkin Gallery, New York, New York

Pierre Apraxine, Marlborough Gallery, Incorporated, New York, New York

Sotheby Parke Bernet, Incorporated, New York, New York

The Library of Congress, Washington, District of Columbia

The New York Public Library, New York, New York

Harper's Bazaar, New York, New York —Robert Brandau

Acknowledgments

The text of this book was set in the film version of Bulmer,
a replica of a type face designed and cut by William Martin about 1790
for William Bulmer (1757-1830) of London. As head of the Shakspeare Press,
Bulmer was one of the most successful and distinguished printers of his time.
Martin employed as models for the Bulmer face the sharp and fine letter-forms of John
Baskerville as well as those of Italian and French printers, especially Bodoni and Didot.

This book was photocomposed by New England Typographic Service, Inc.,
Bloomfield, Connecticut; printed in two colors by Rapoport Printing Corporation,
New York, New York, using their Stonetone Process; and bound by American
Book–Stratford Press, Saddle Brook, New Jersey.

R. D. Scudellari directed the graphics and designed the book.
Ellen McNeilly directed the production and manufacturing.
Neal T. Jones supervised the manuscript and proofs.

Graphics